Blooming Mandala coloring book

Volume 1

Features:
- 50 outstanding stress-relieving Mandala designs, designed to engage and spark imagination to unleash your inner creativity.
- Different levels of detail, from easy to difficult (for different eyes). Pick a picture depending on your mood and start your de-stressing journey.

© Copyright 2016

All rights reserved. No part of this book may be reproduced or used in any way or form or by any means whether electronic or mechanical, this means that you cannot record or photocopy any material ideas or tips that are provided in this book.

Illustrated by Ineta Misnika

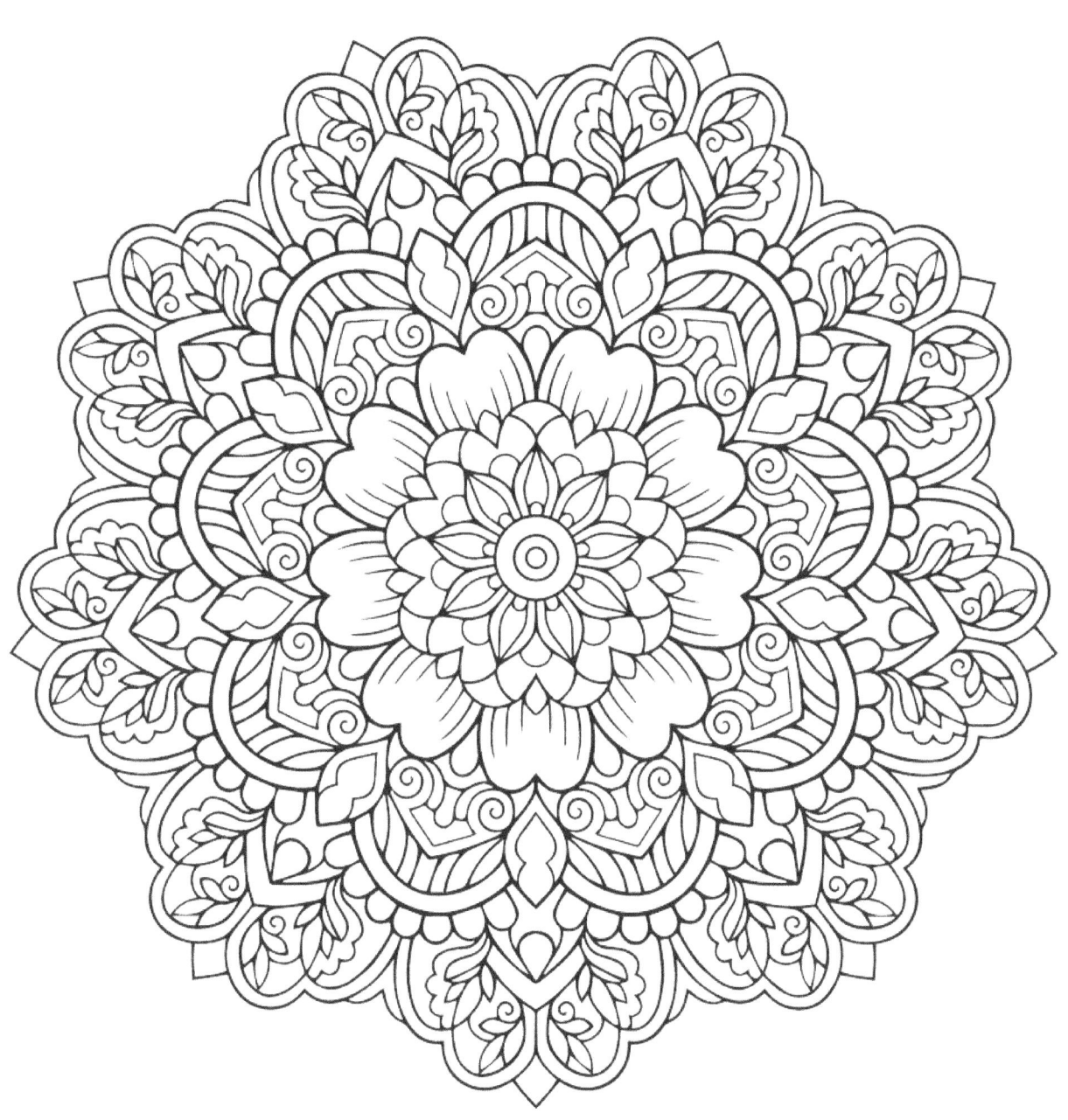

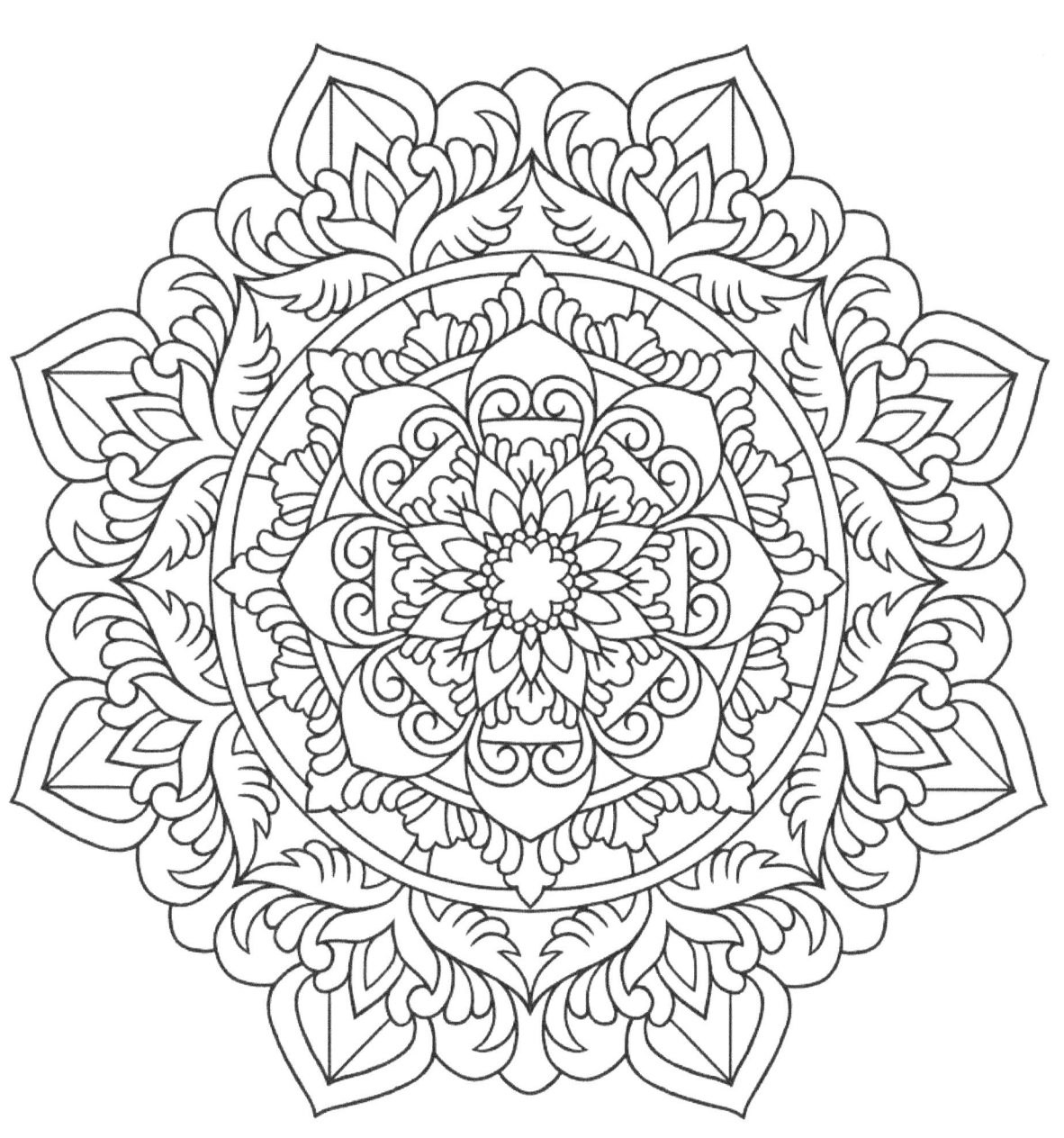

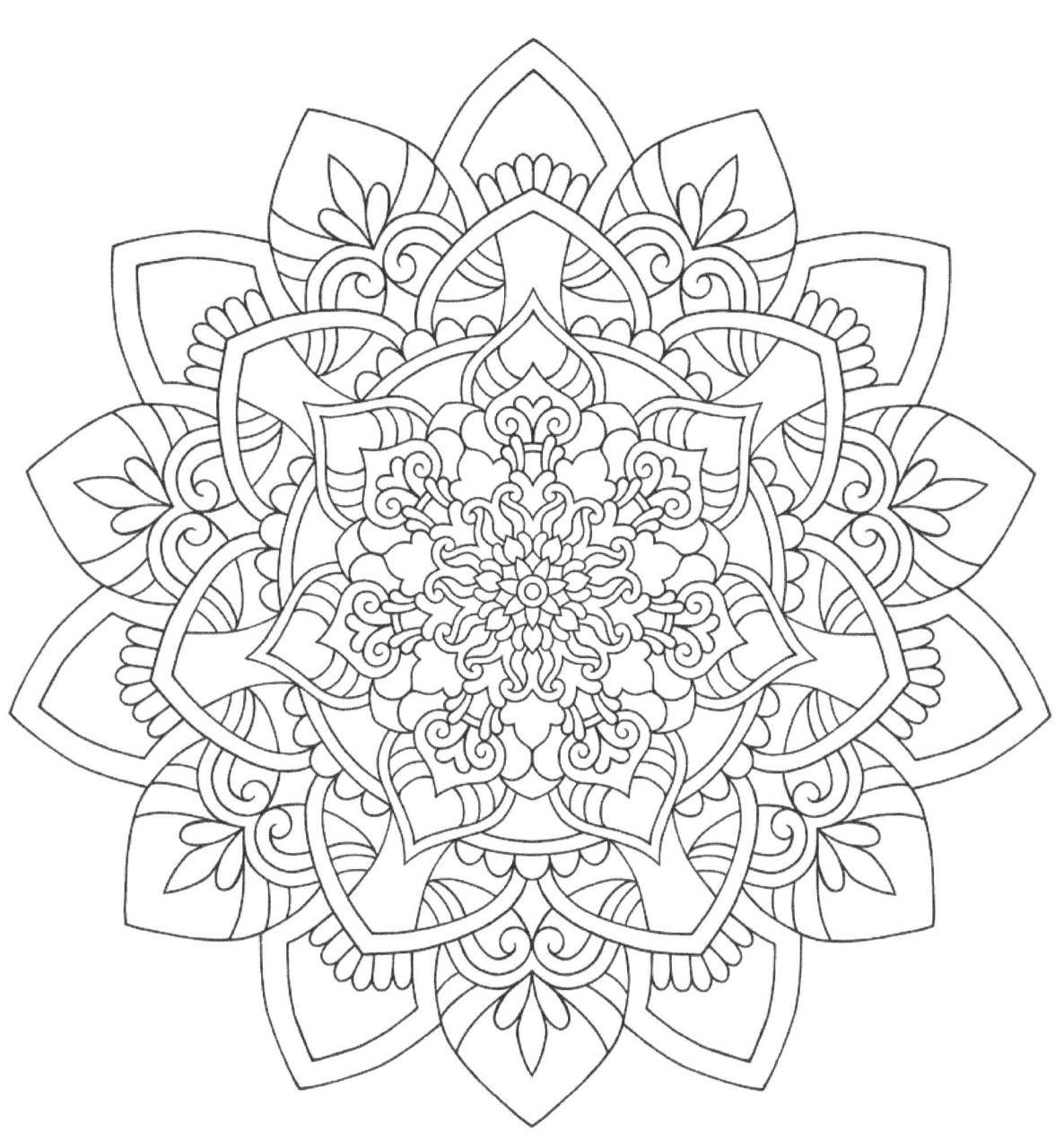

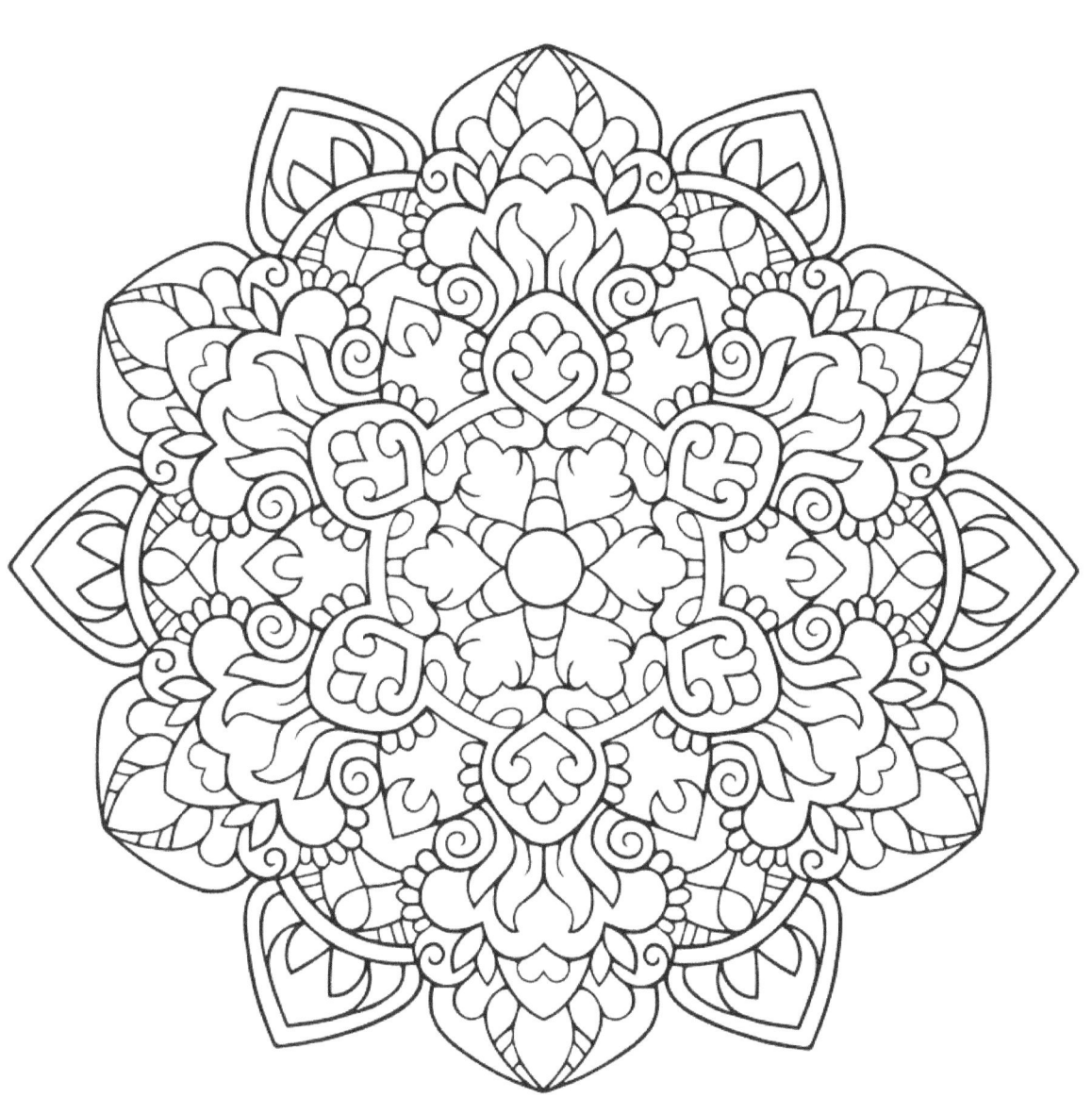

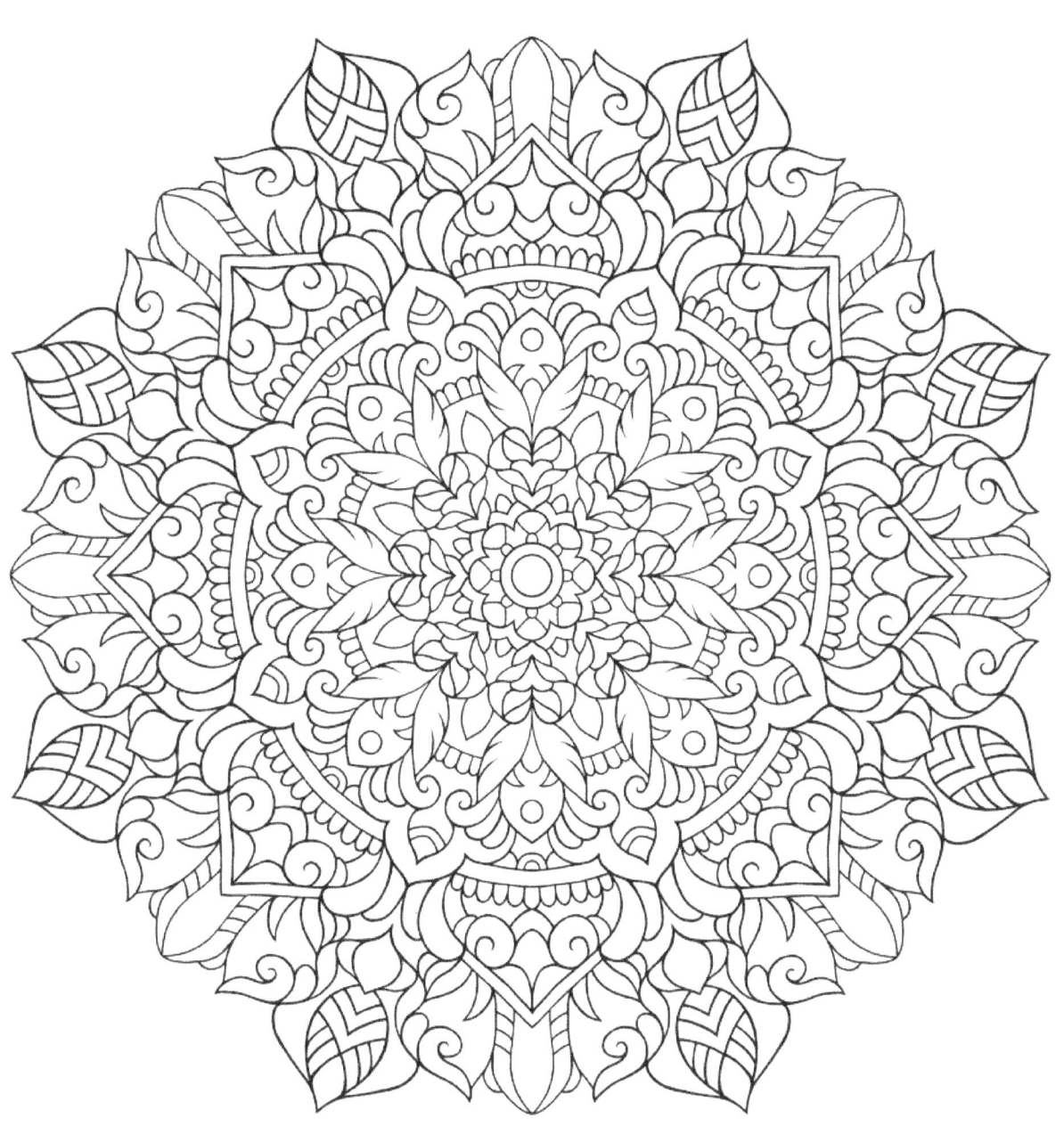

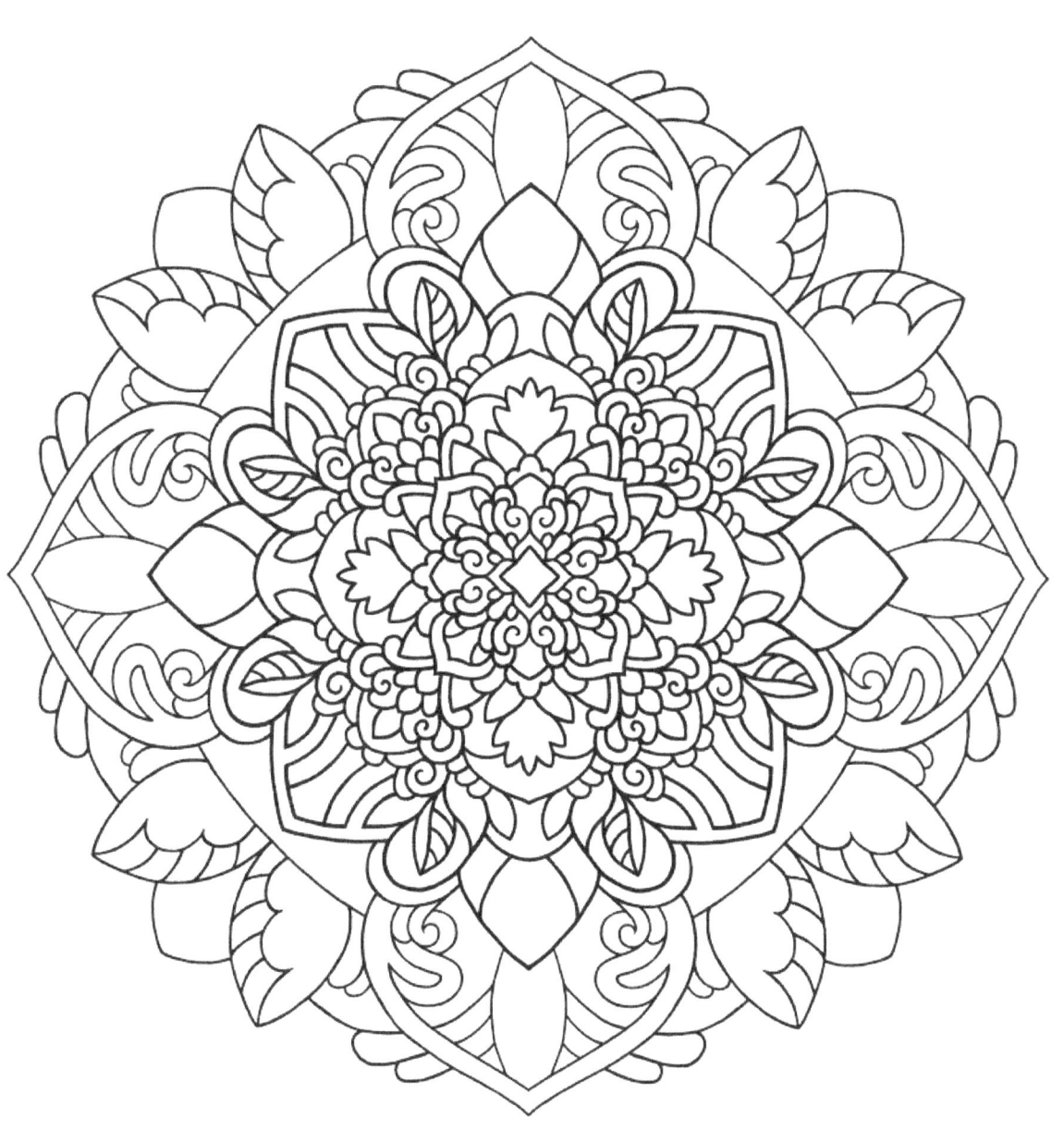

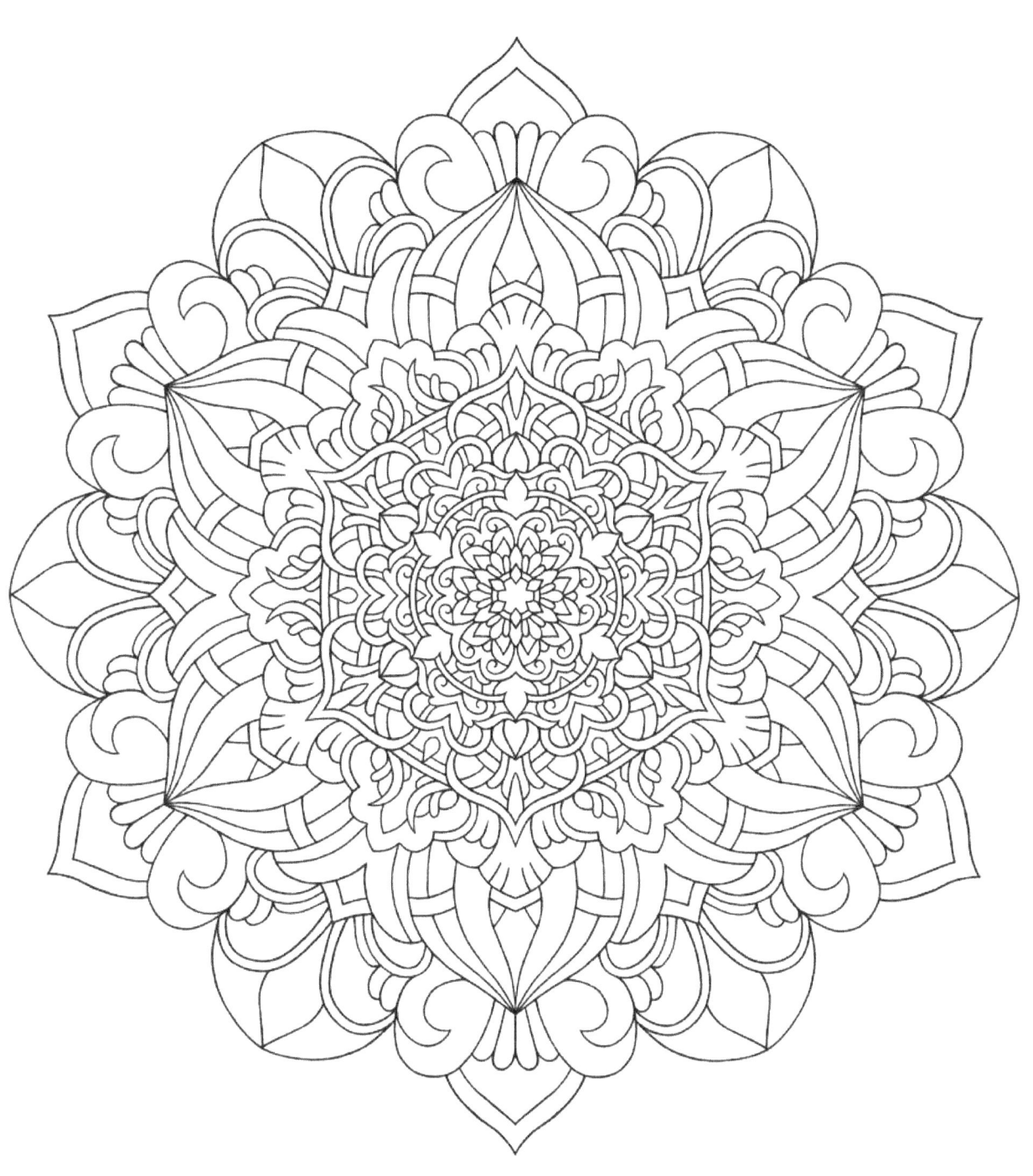

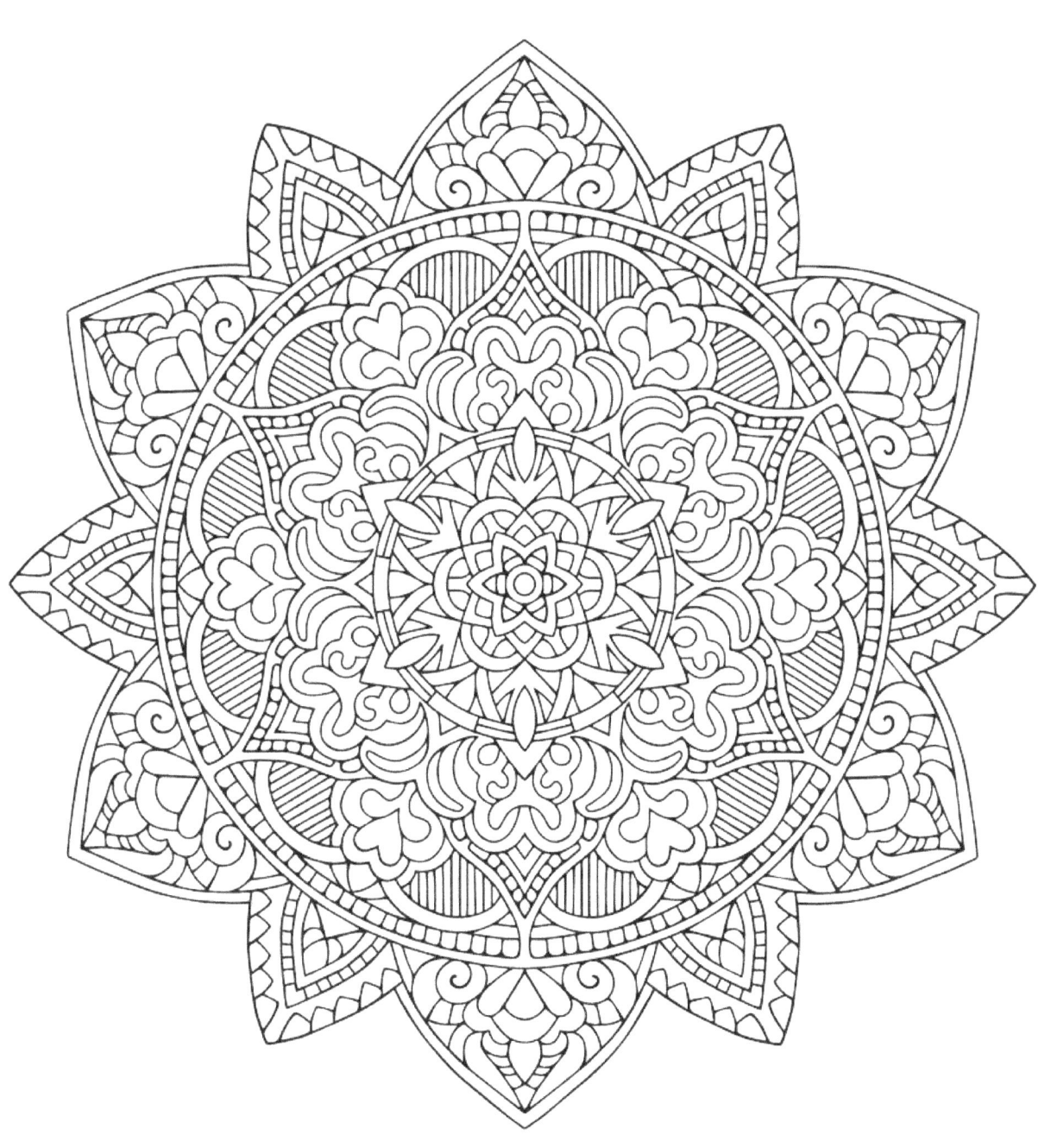

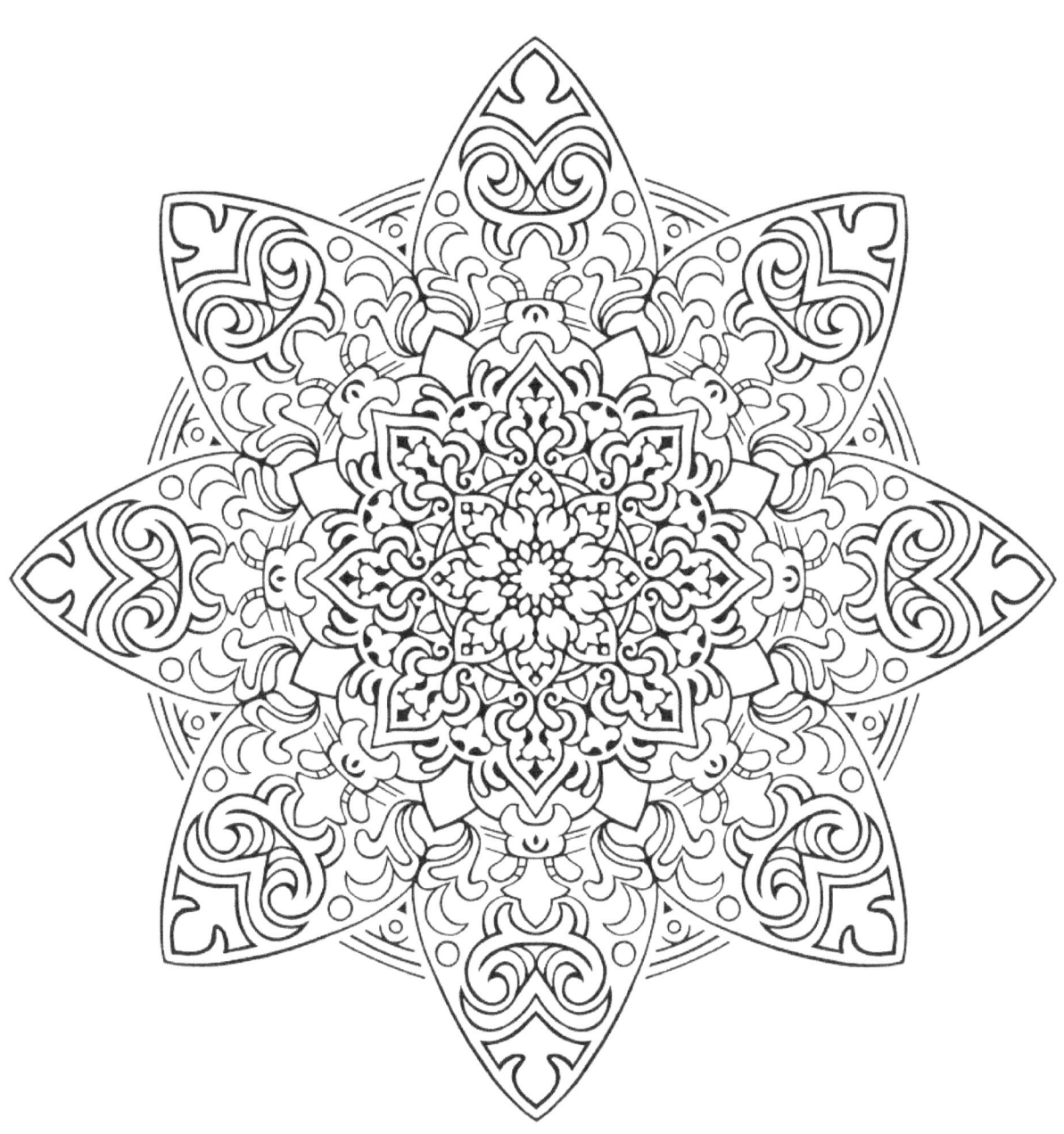

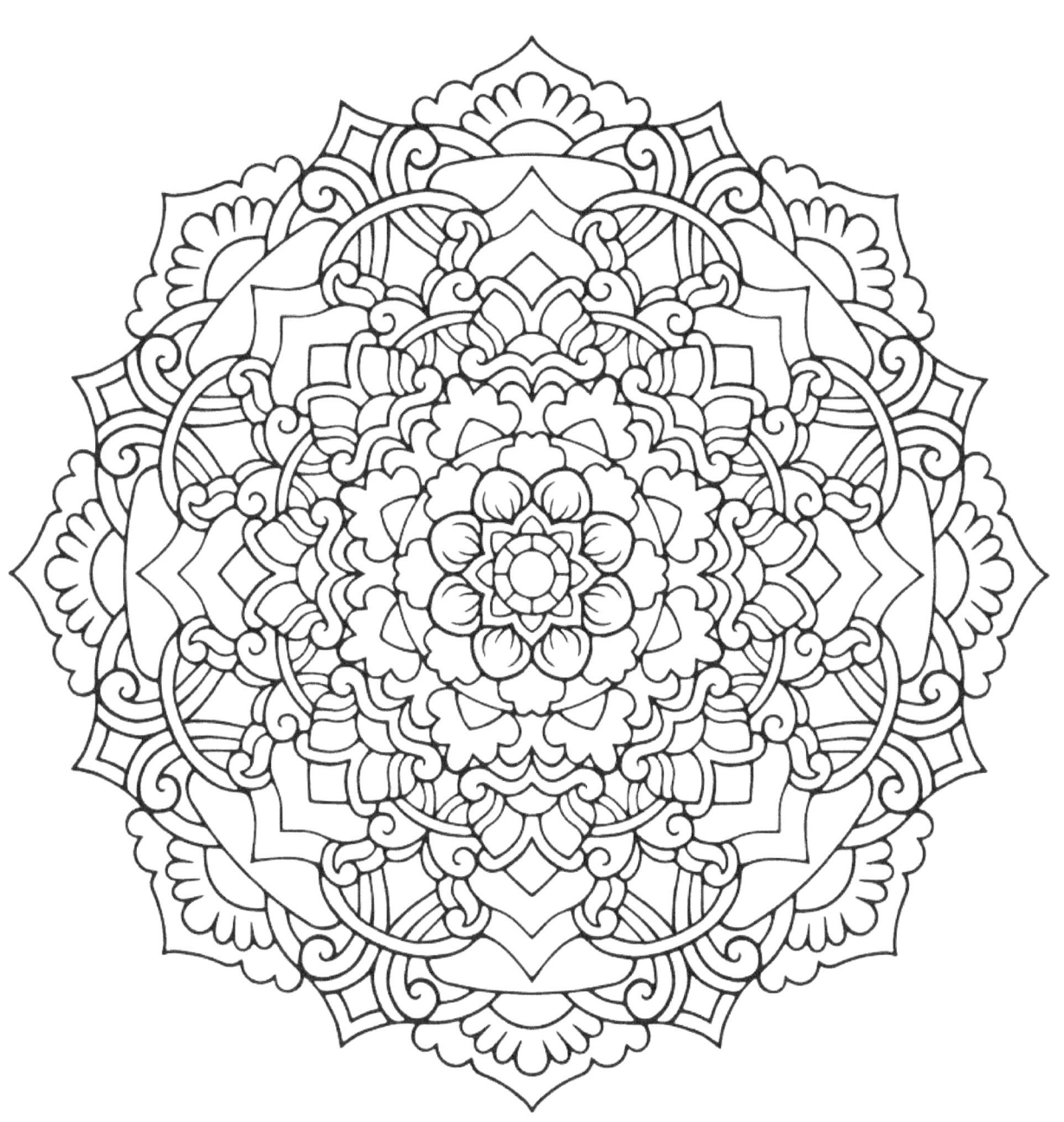

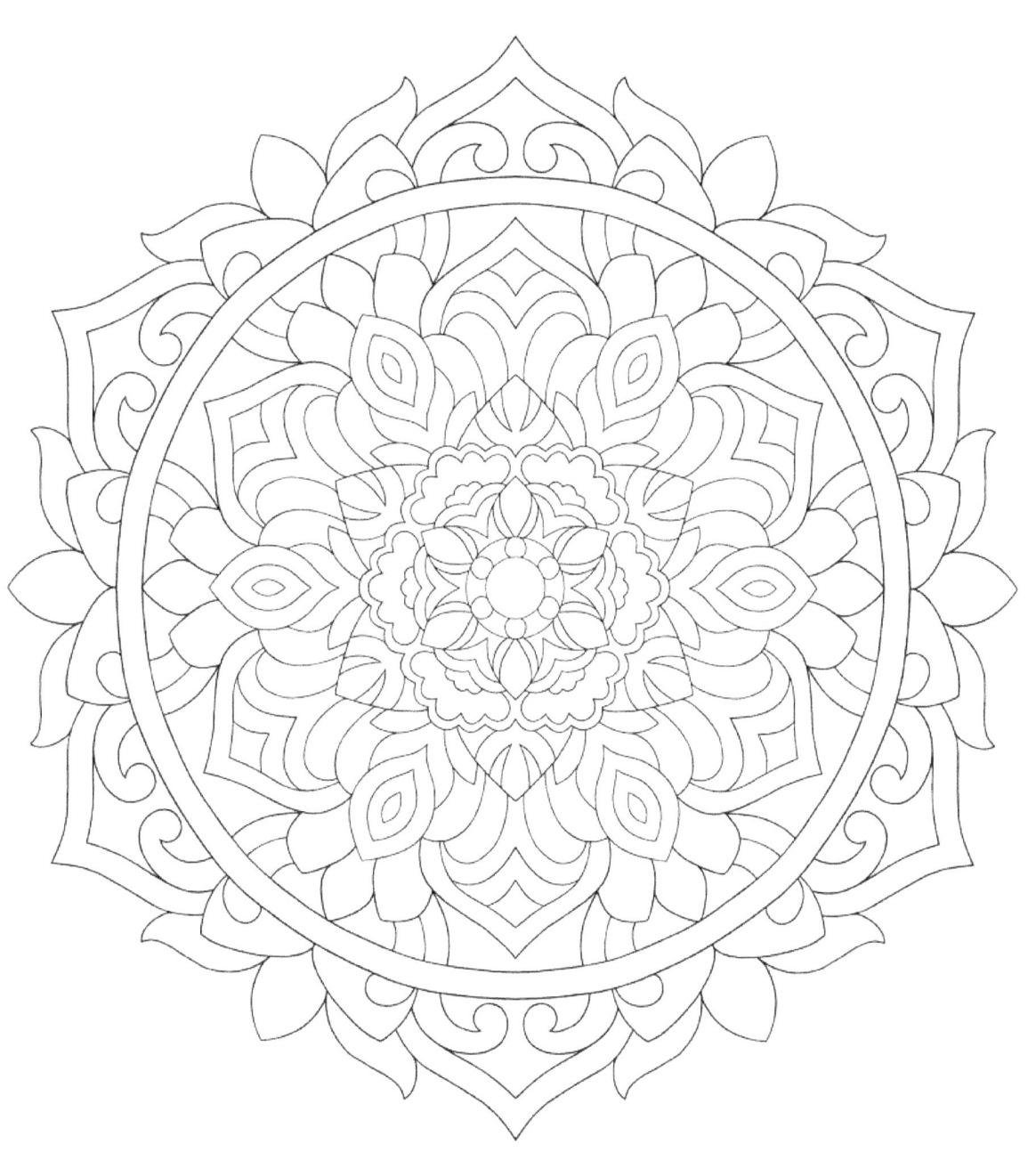

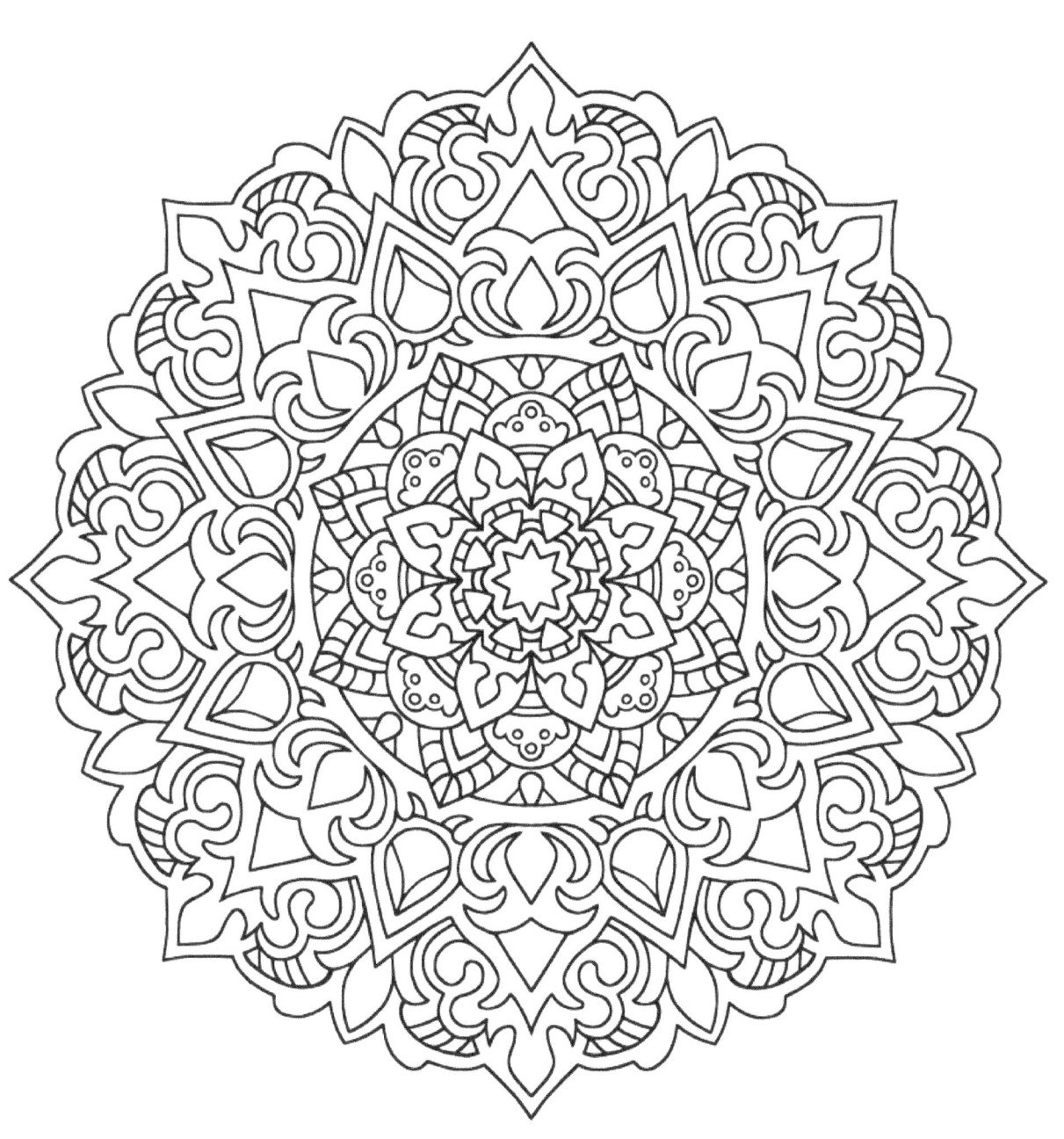

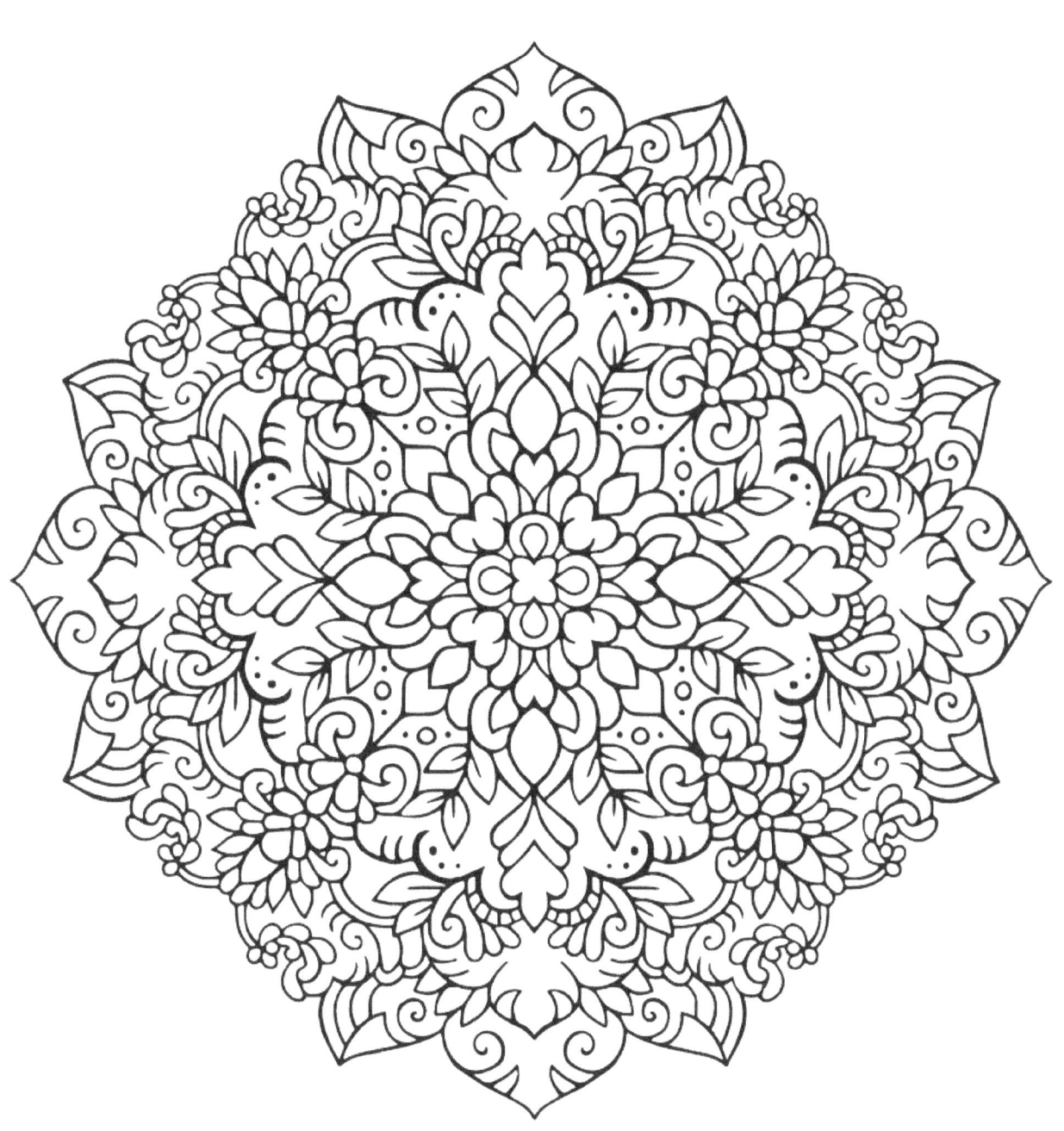

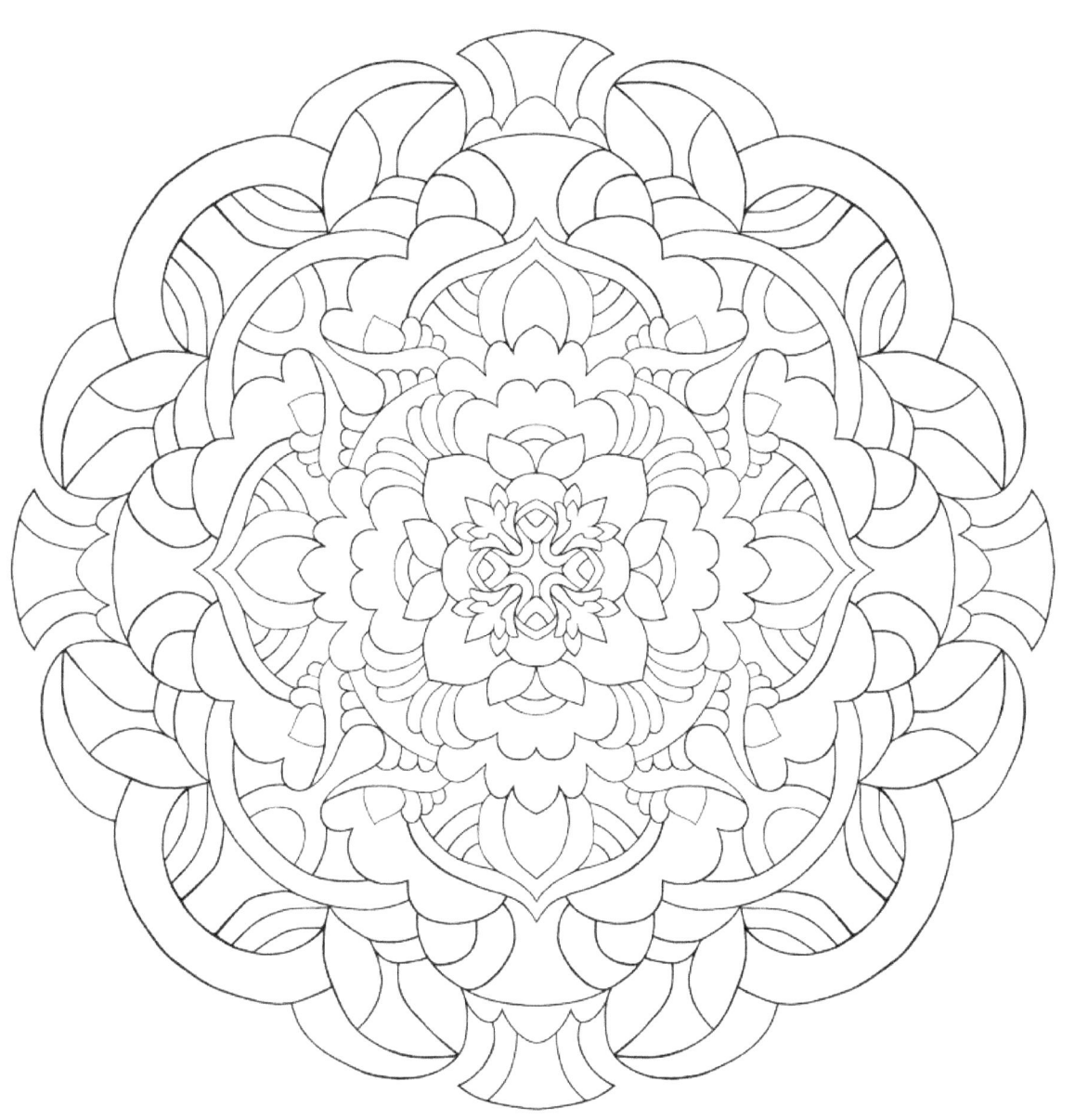

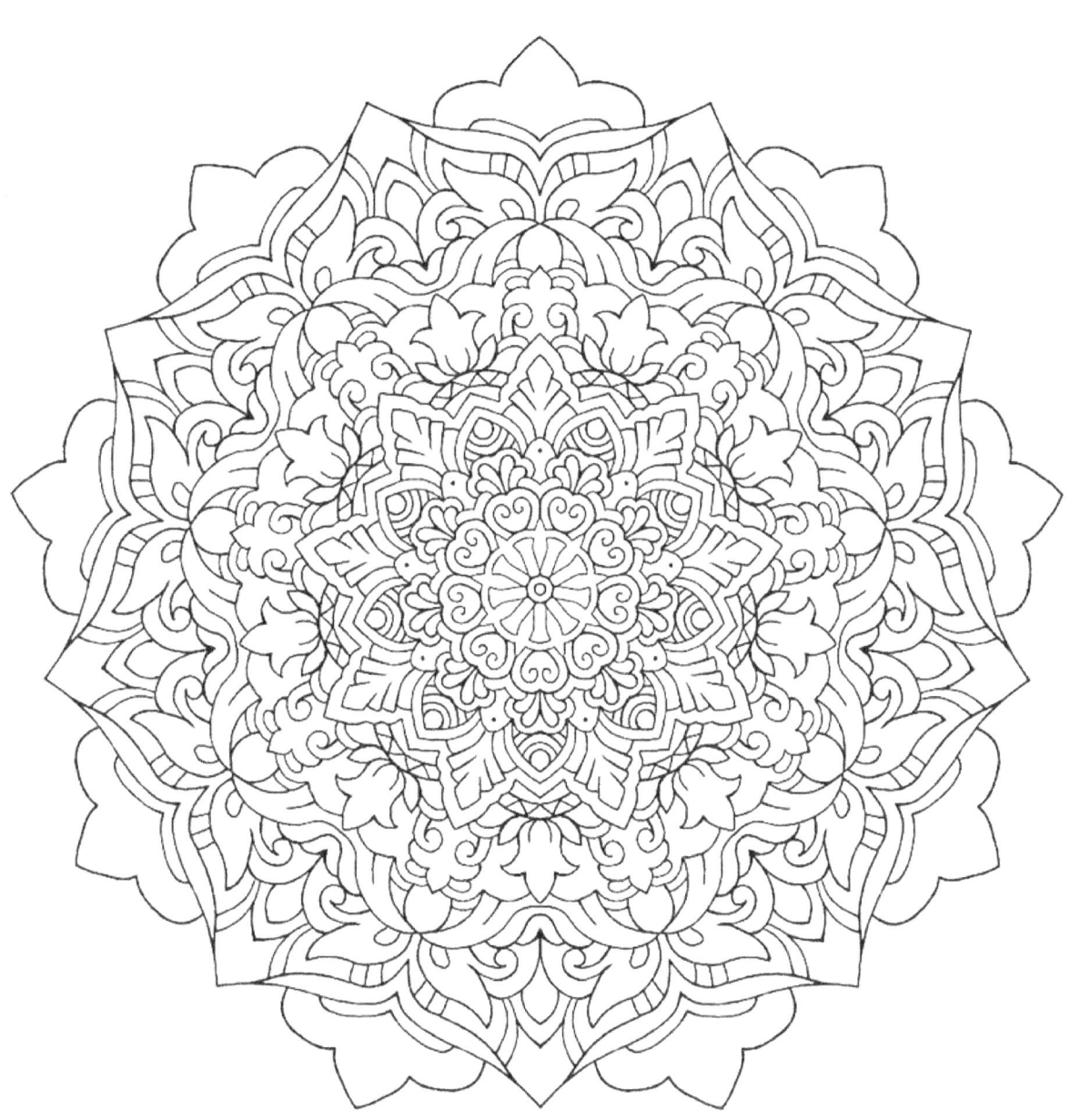

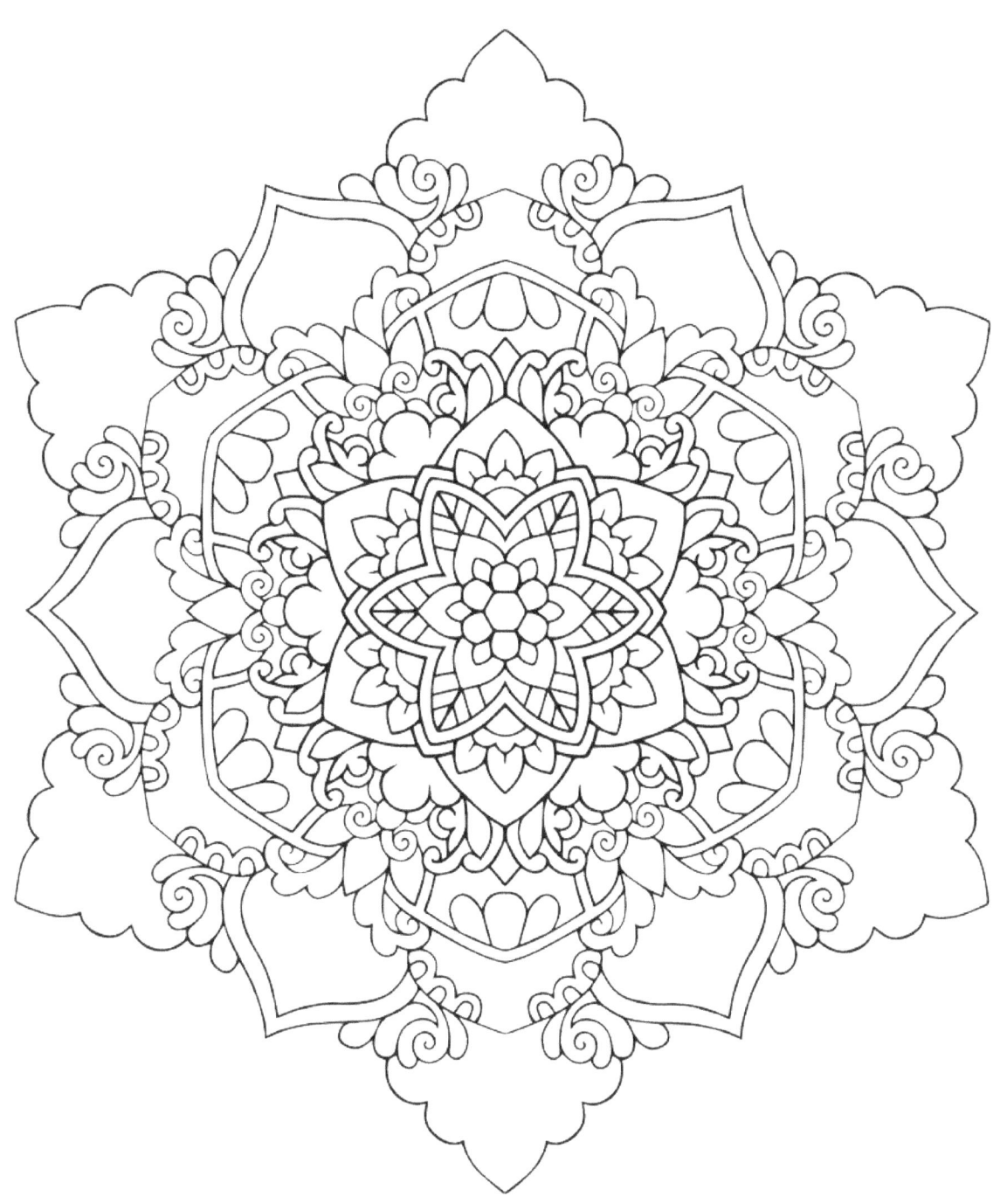

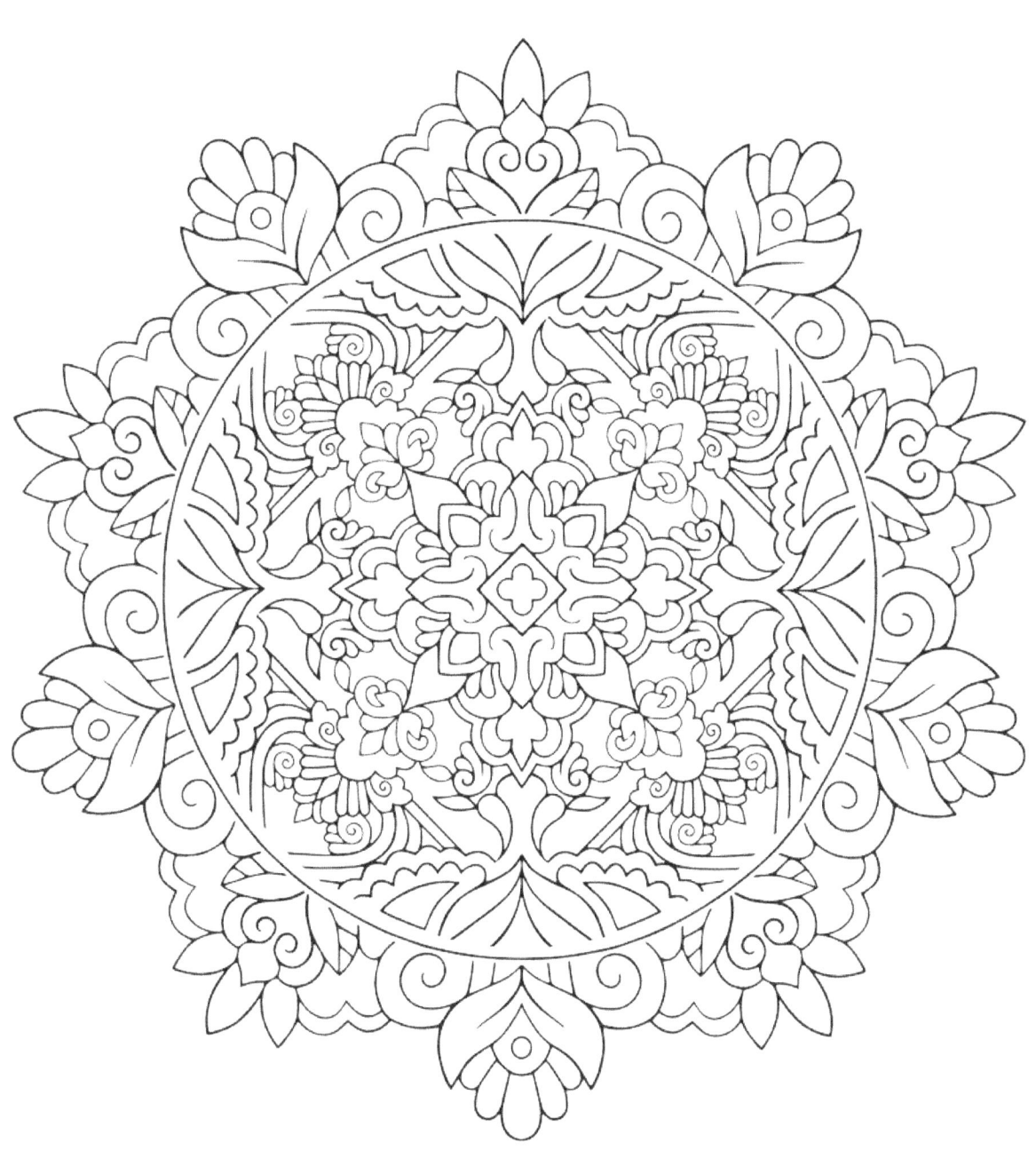

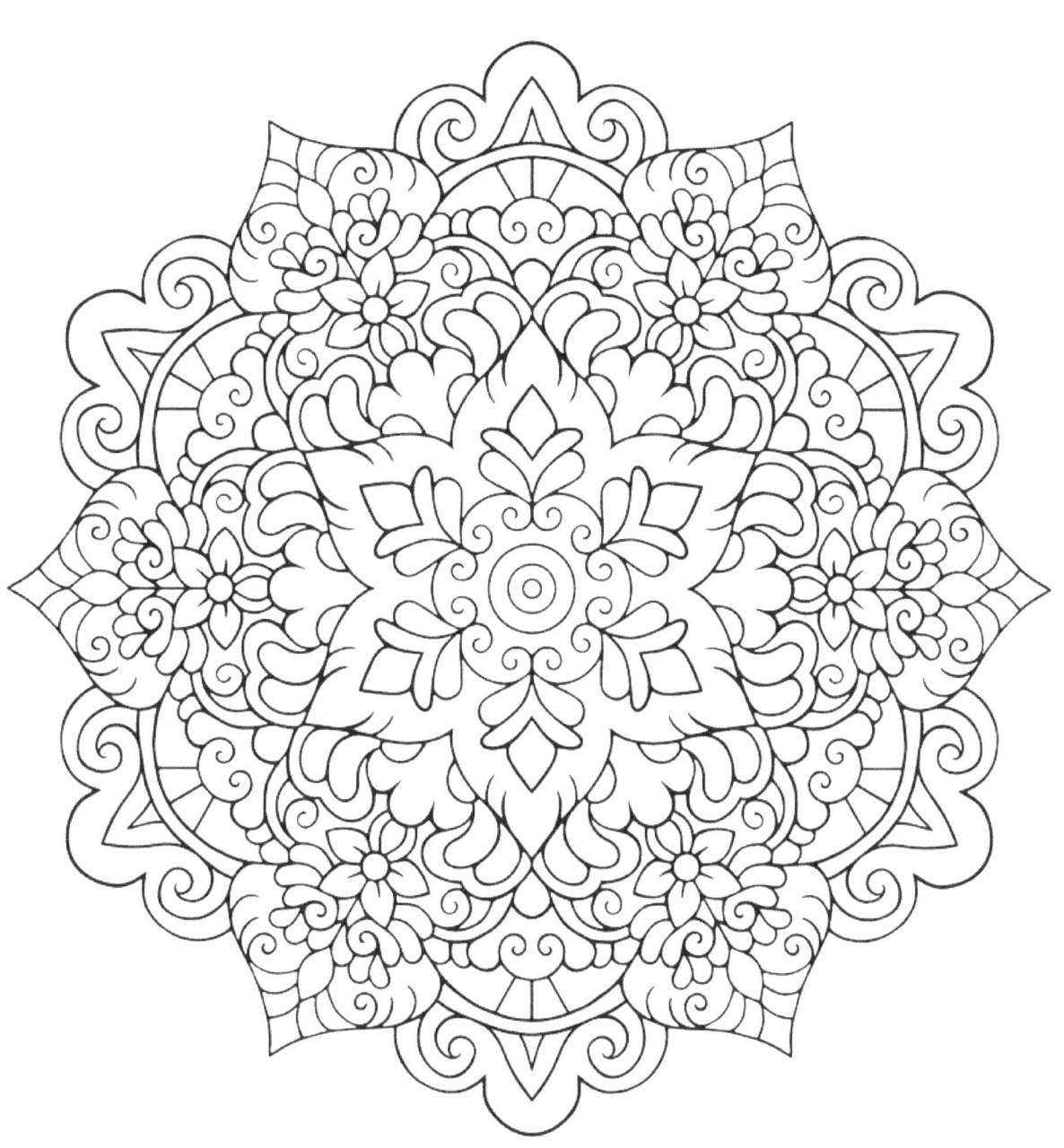

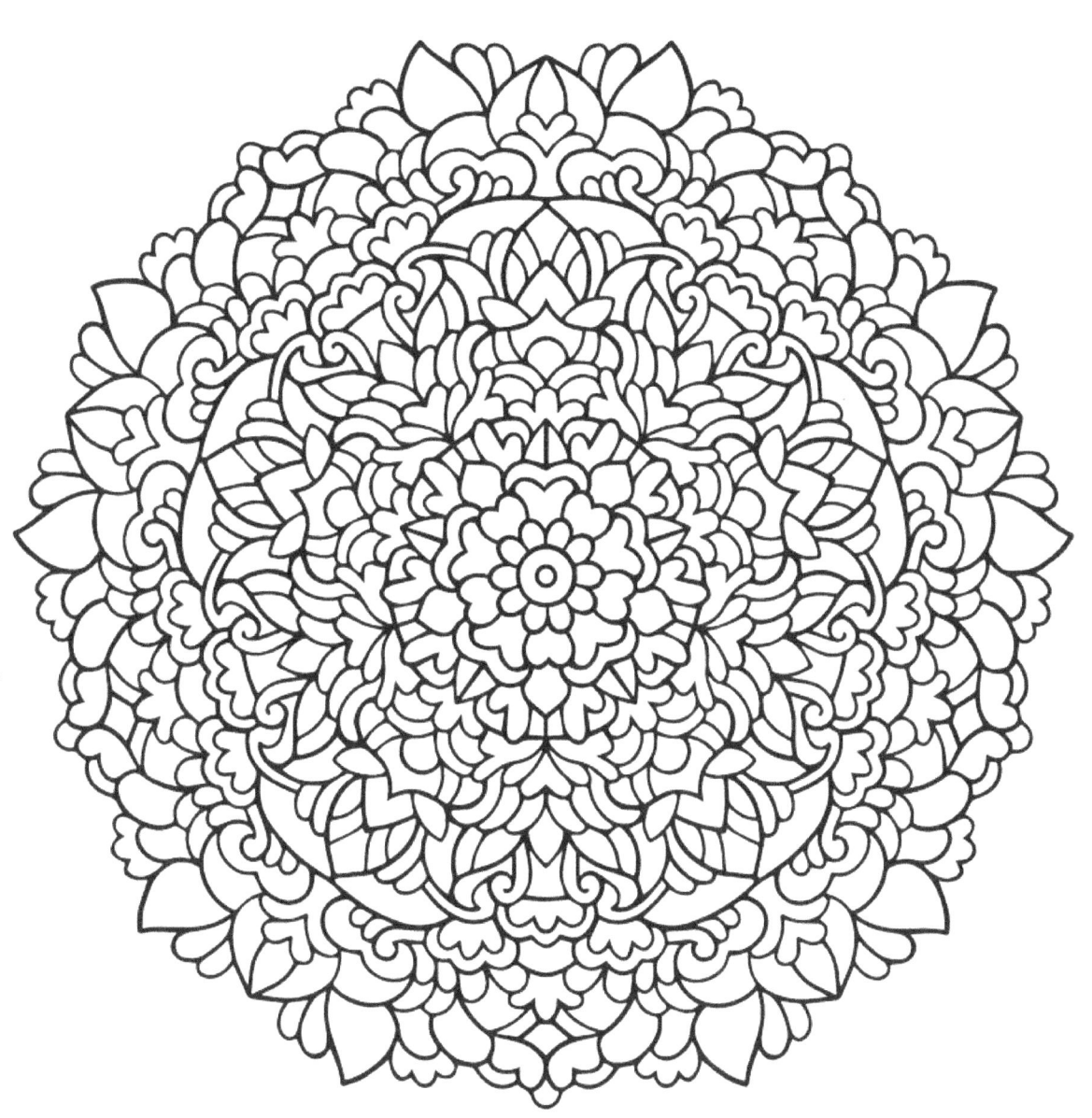

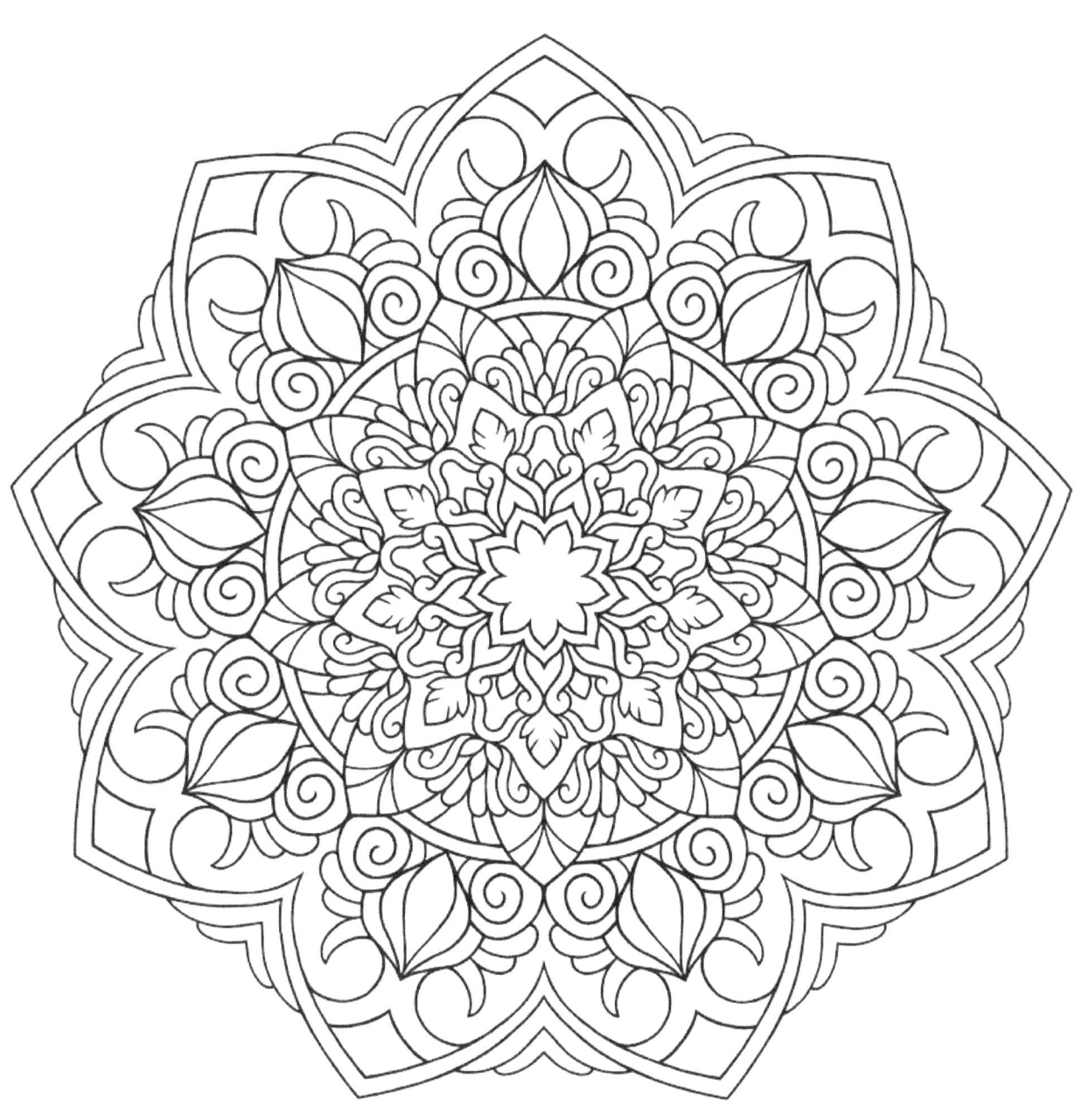

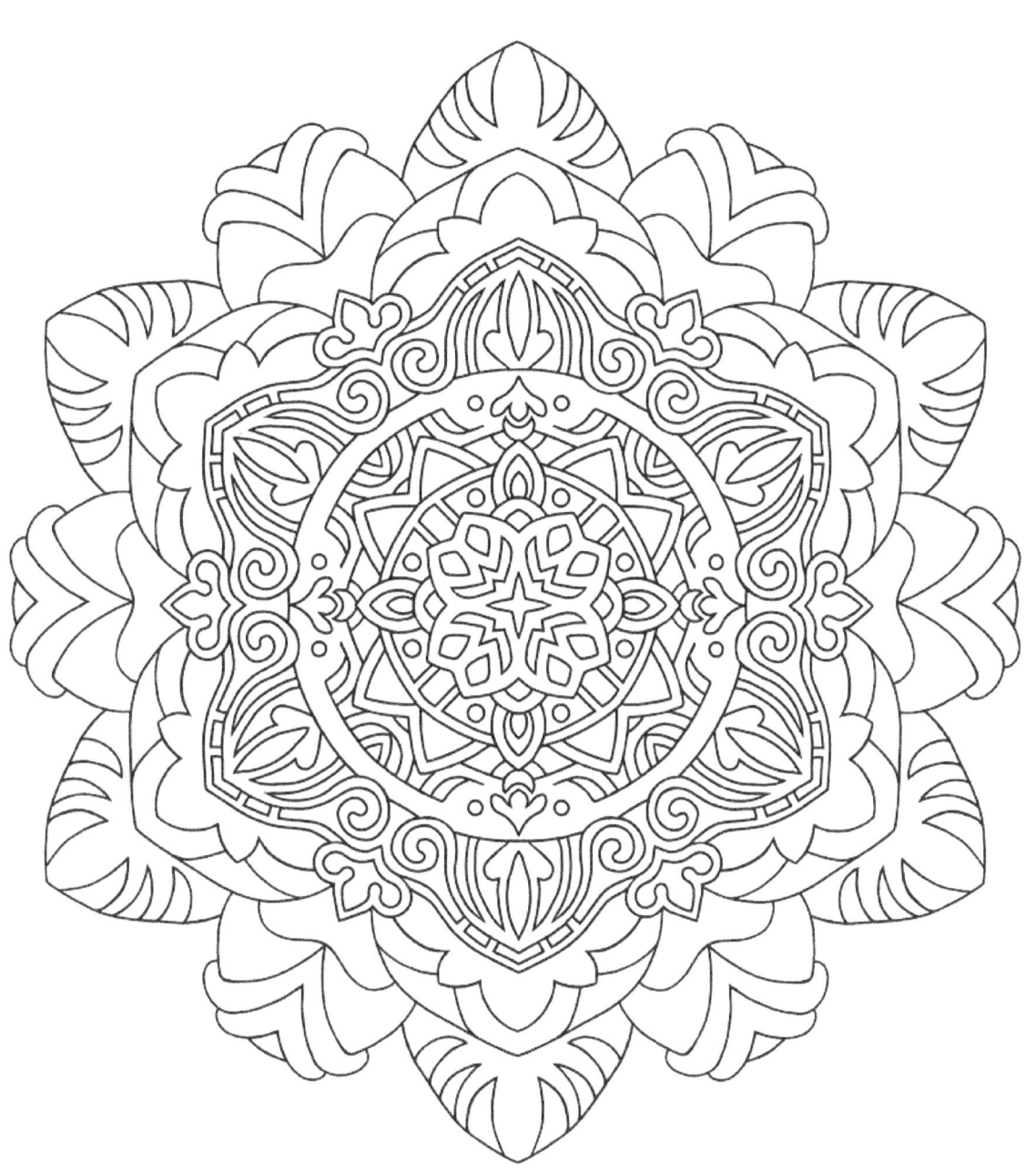

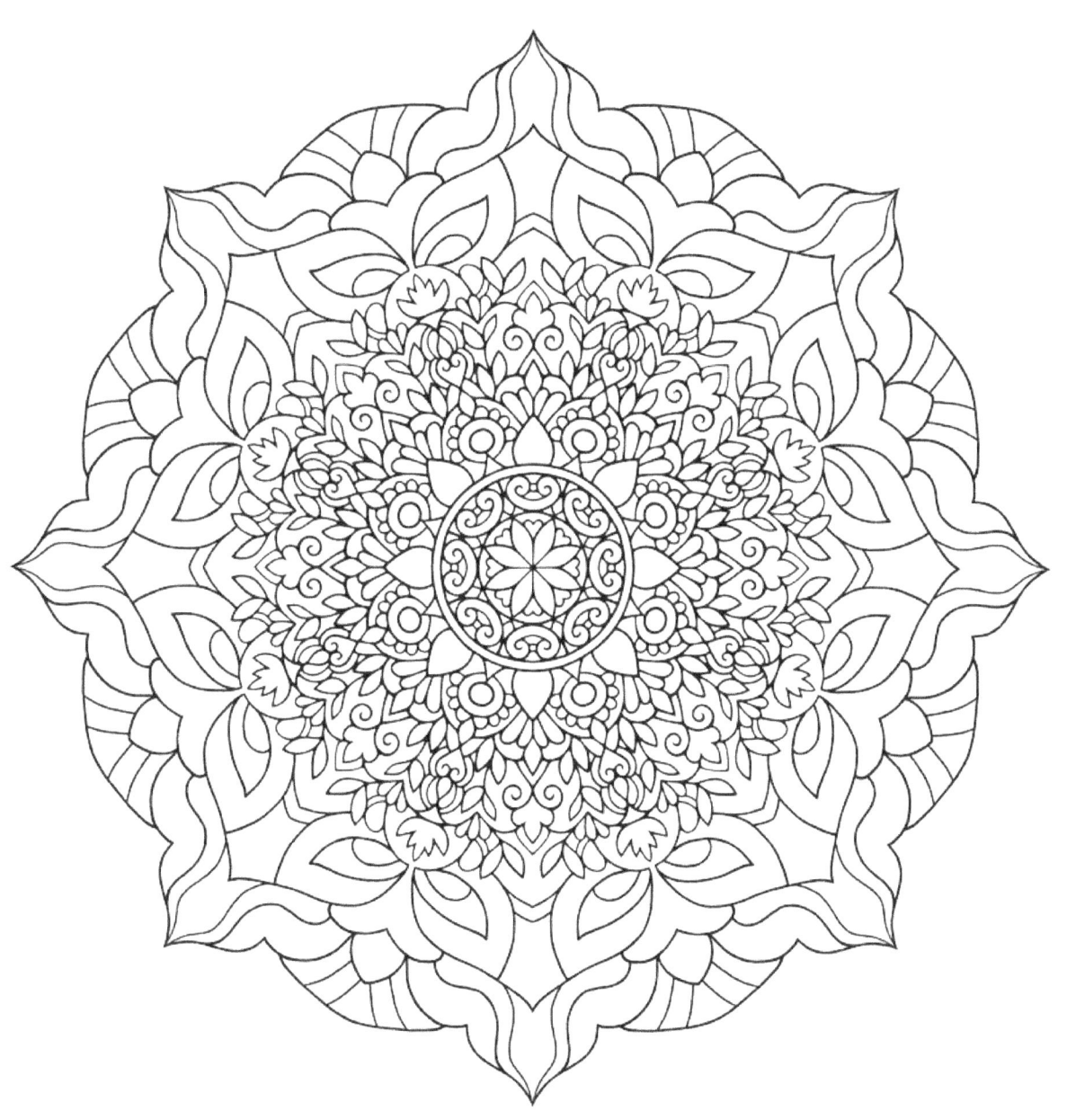

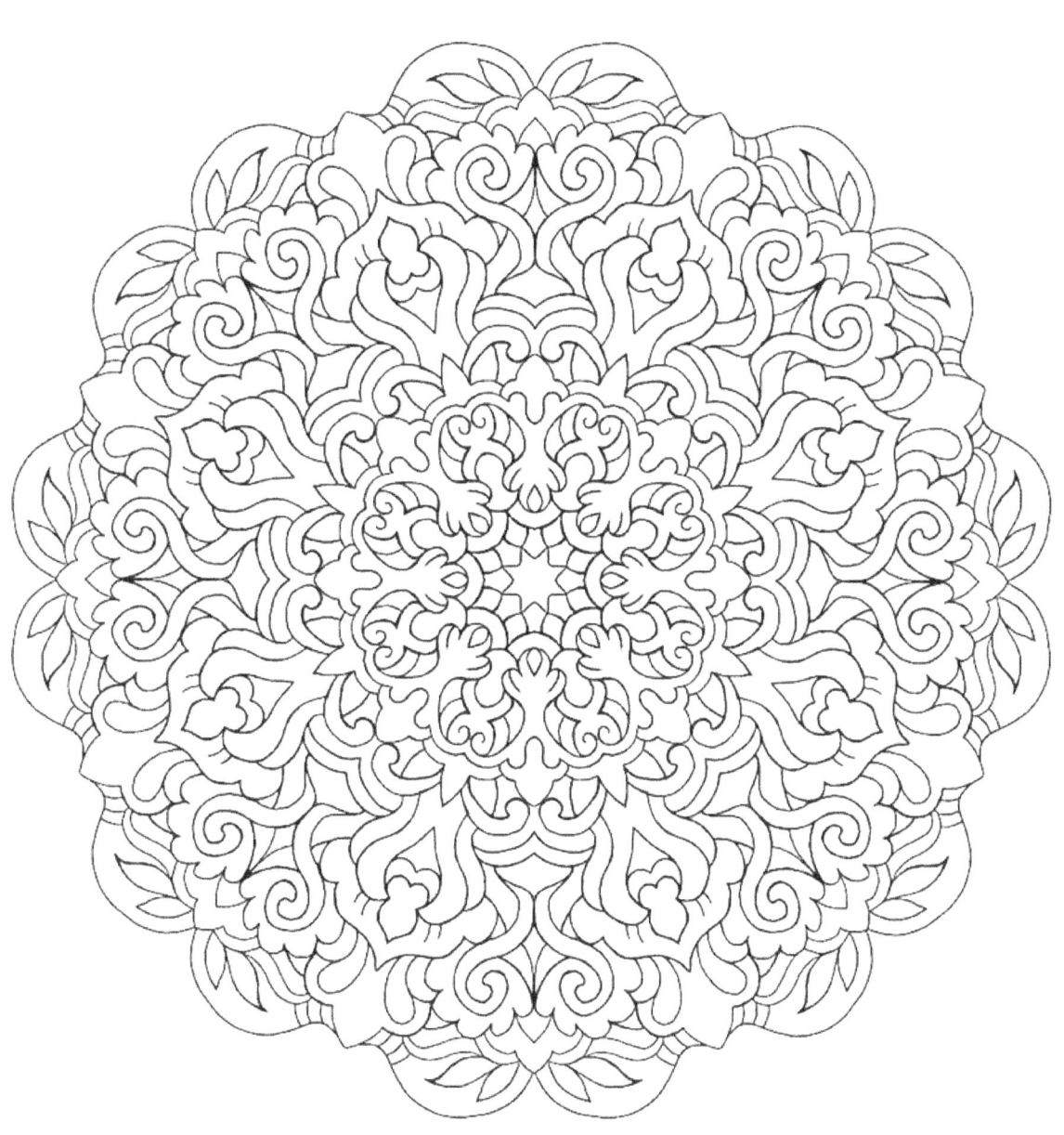

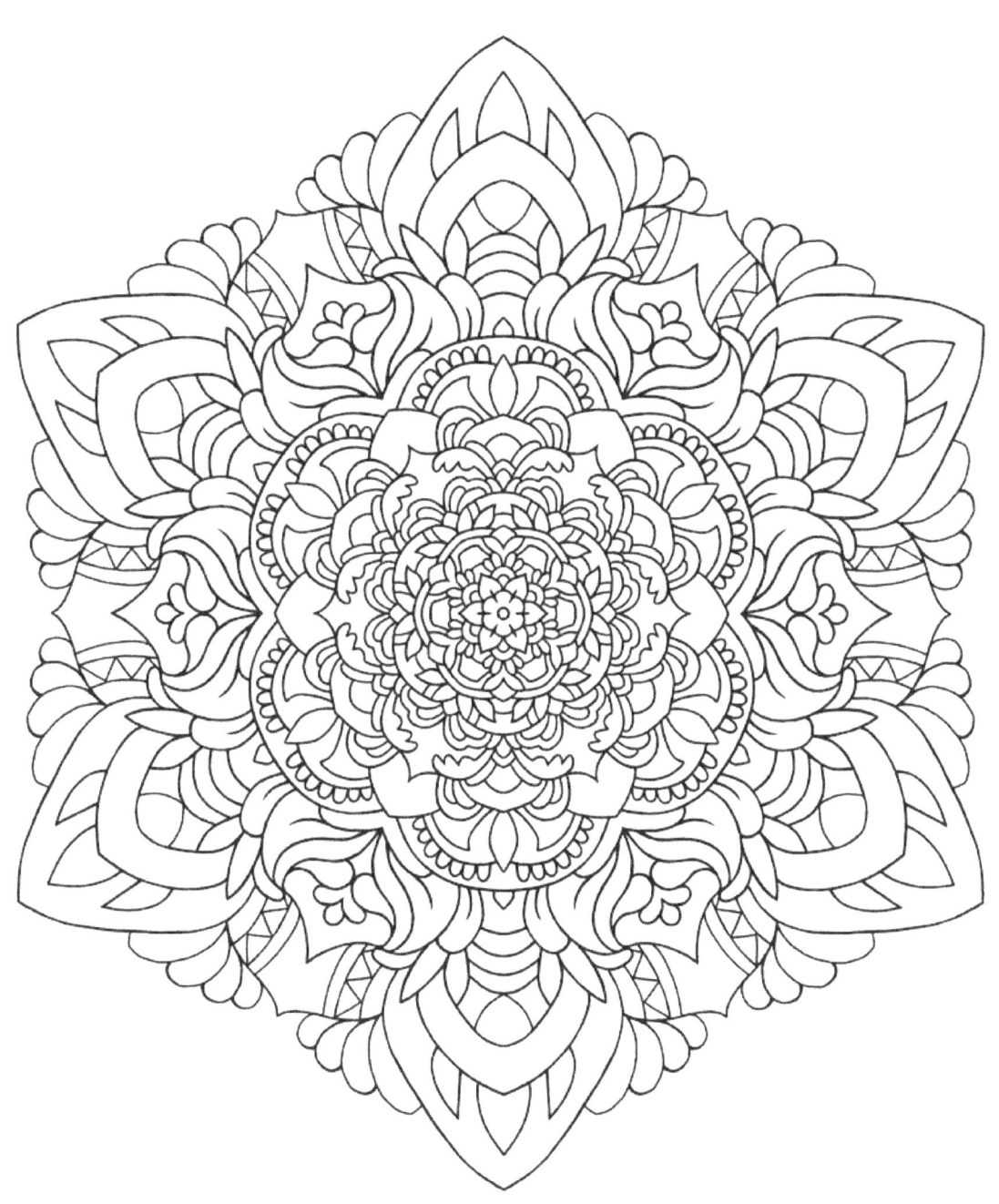

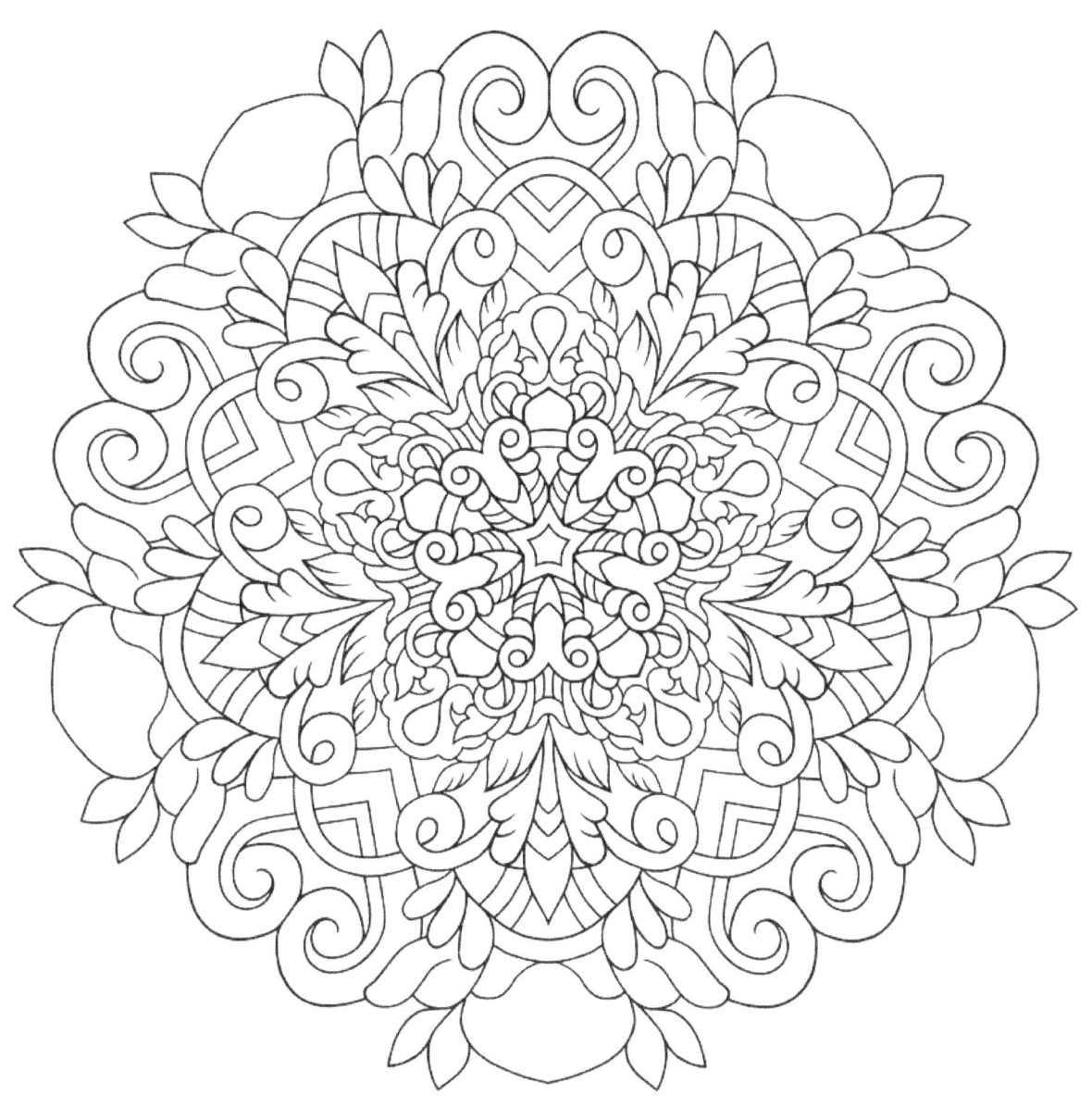

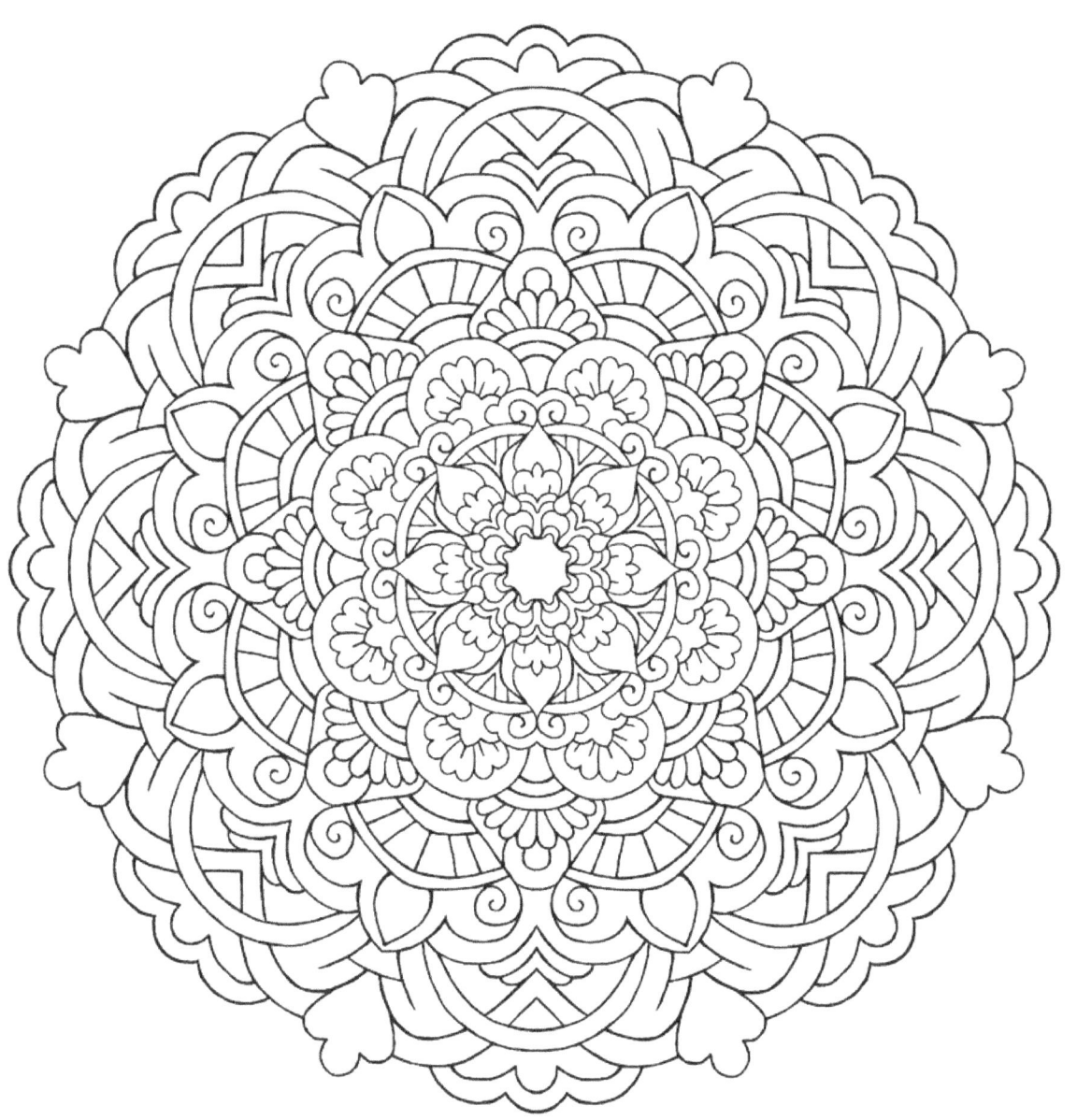

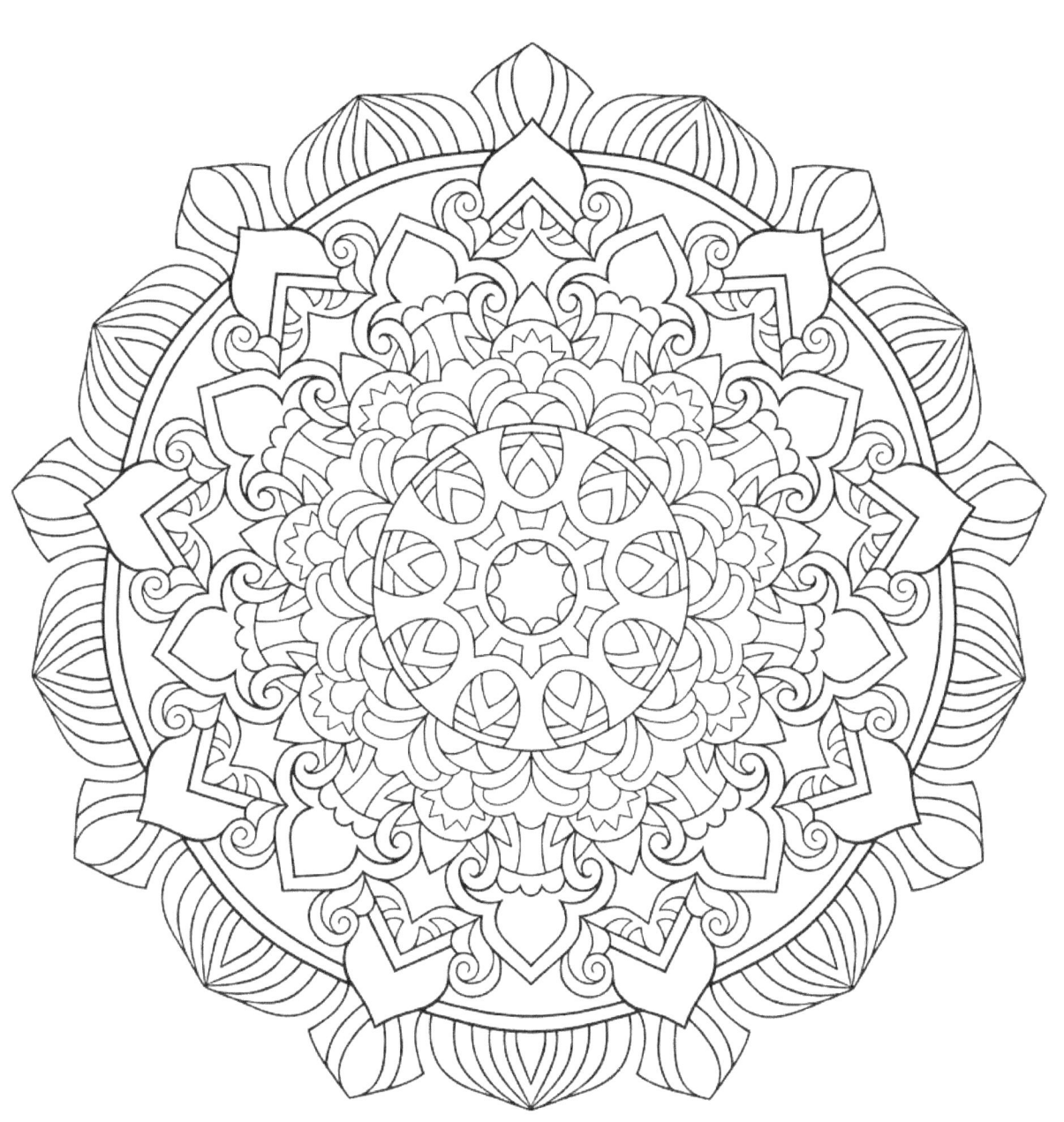

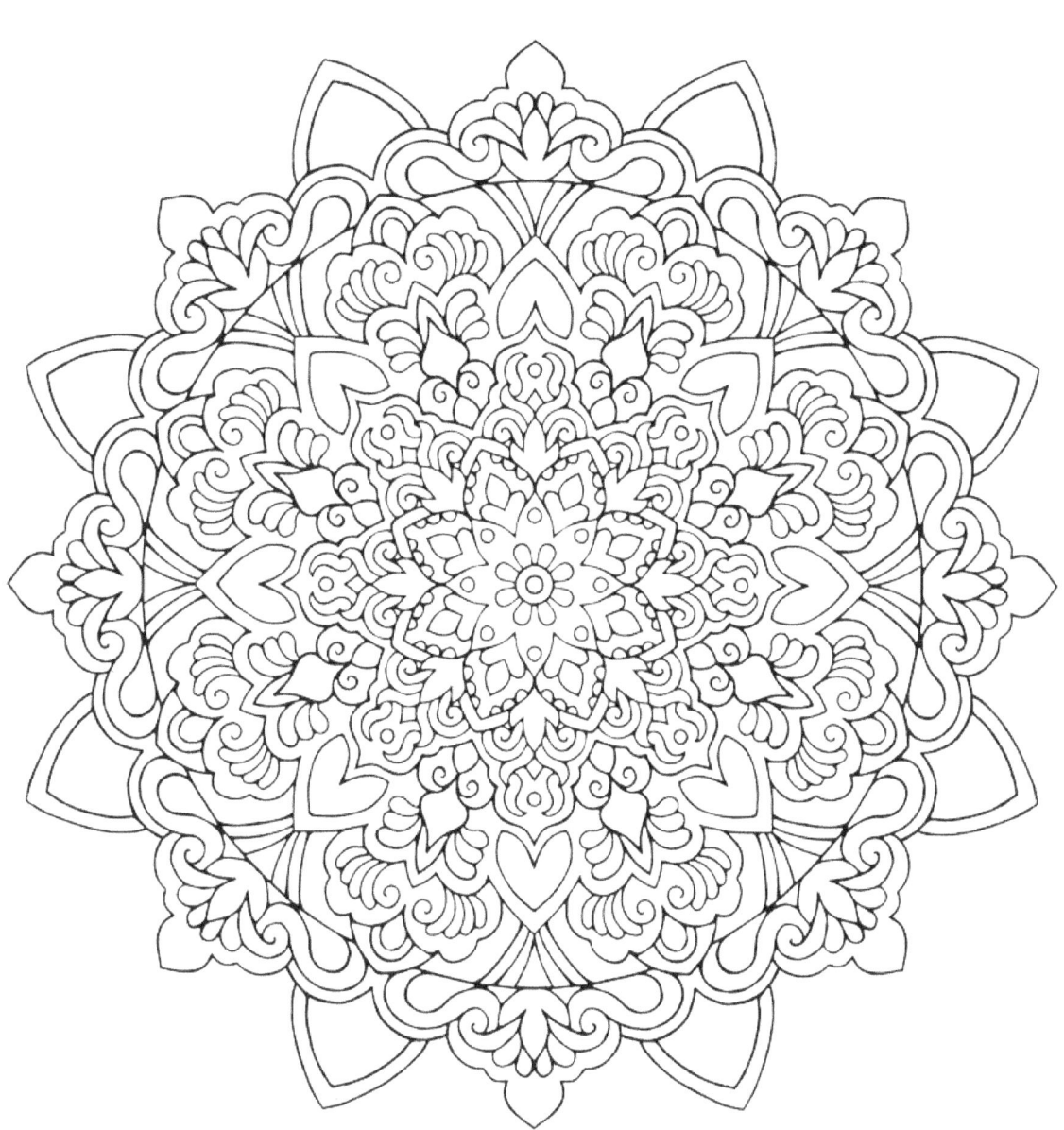

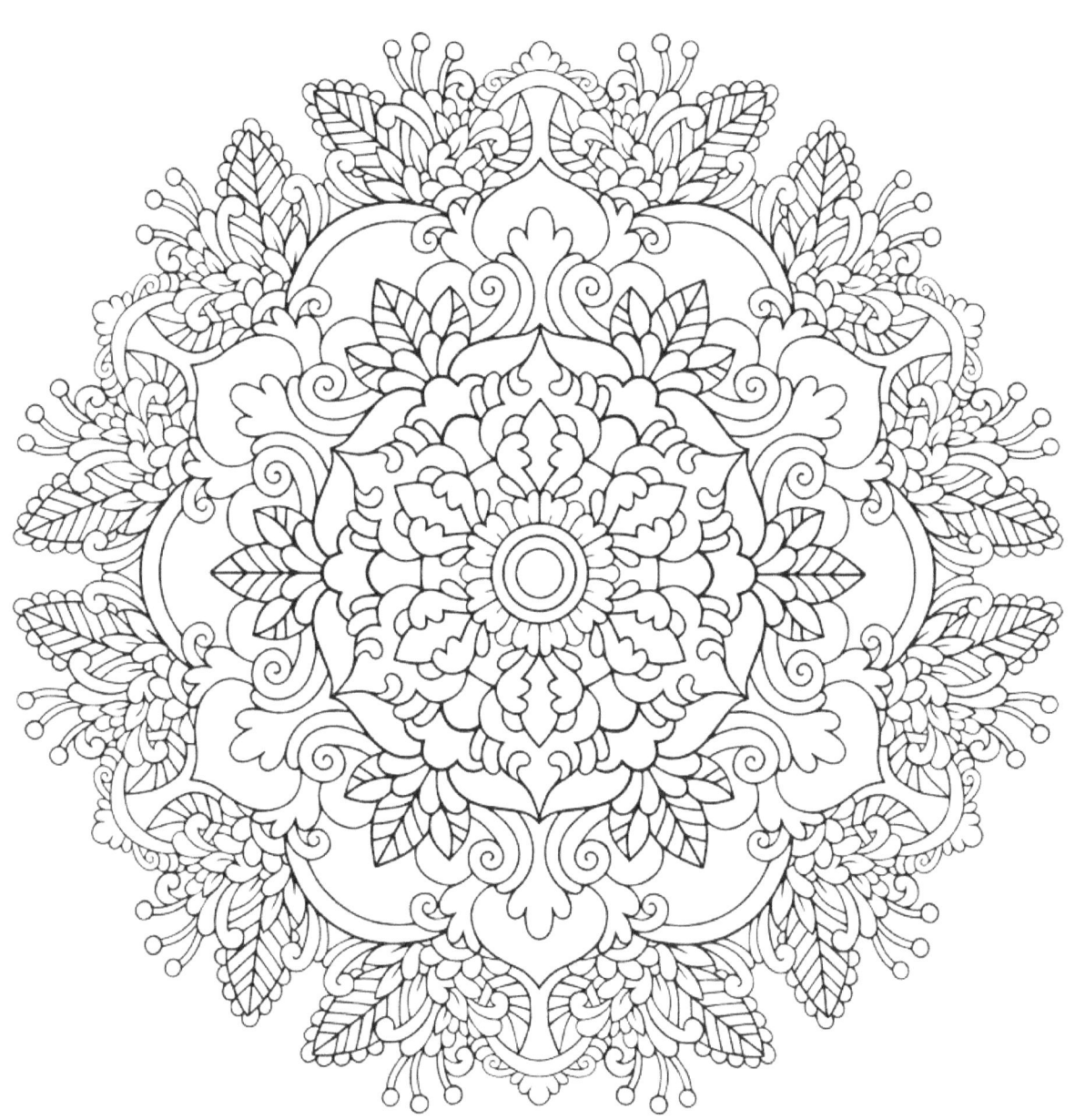

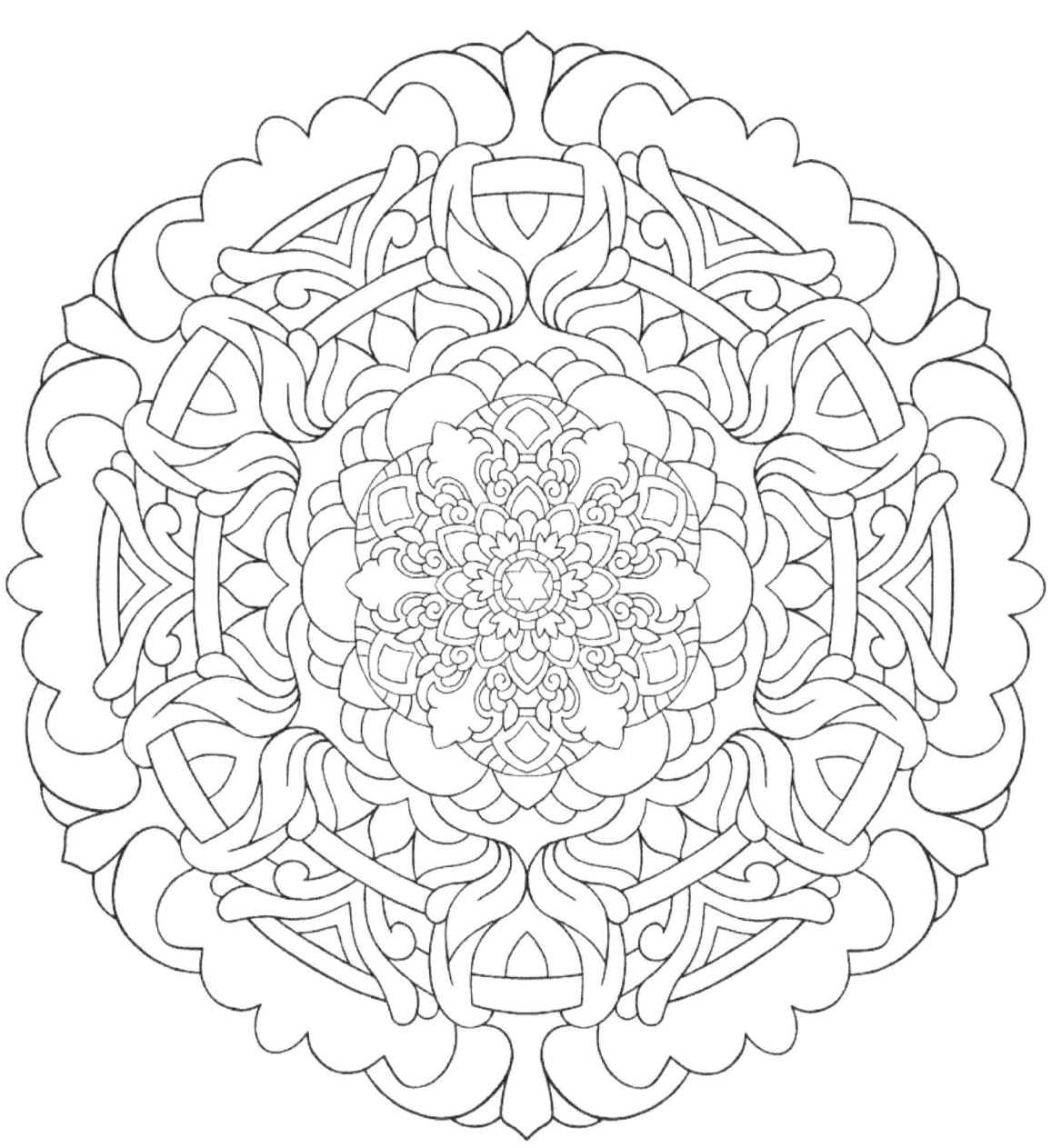

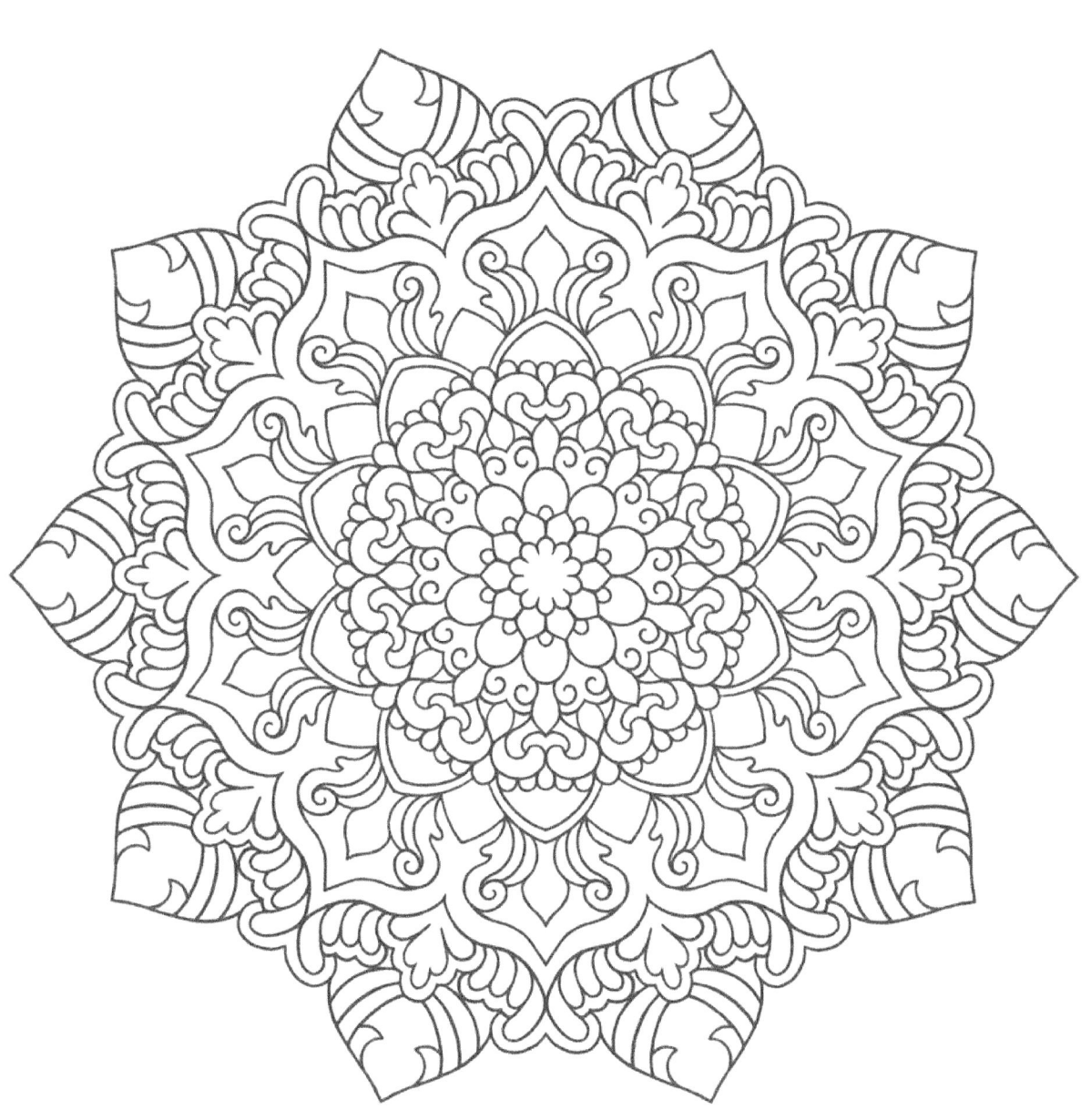

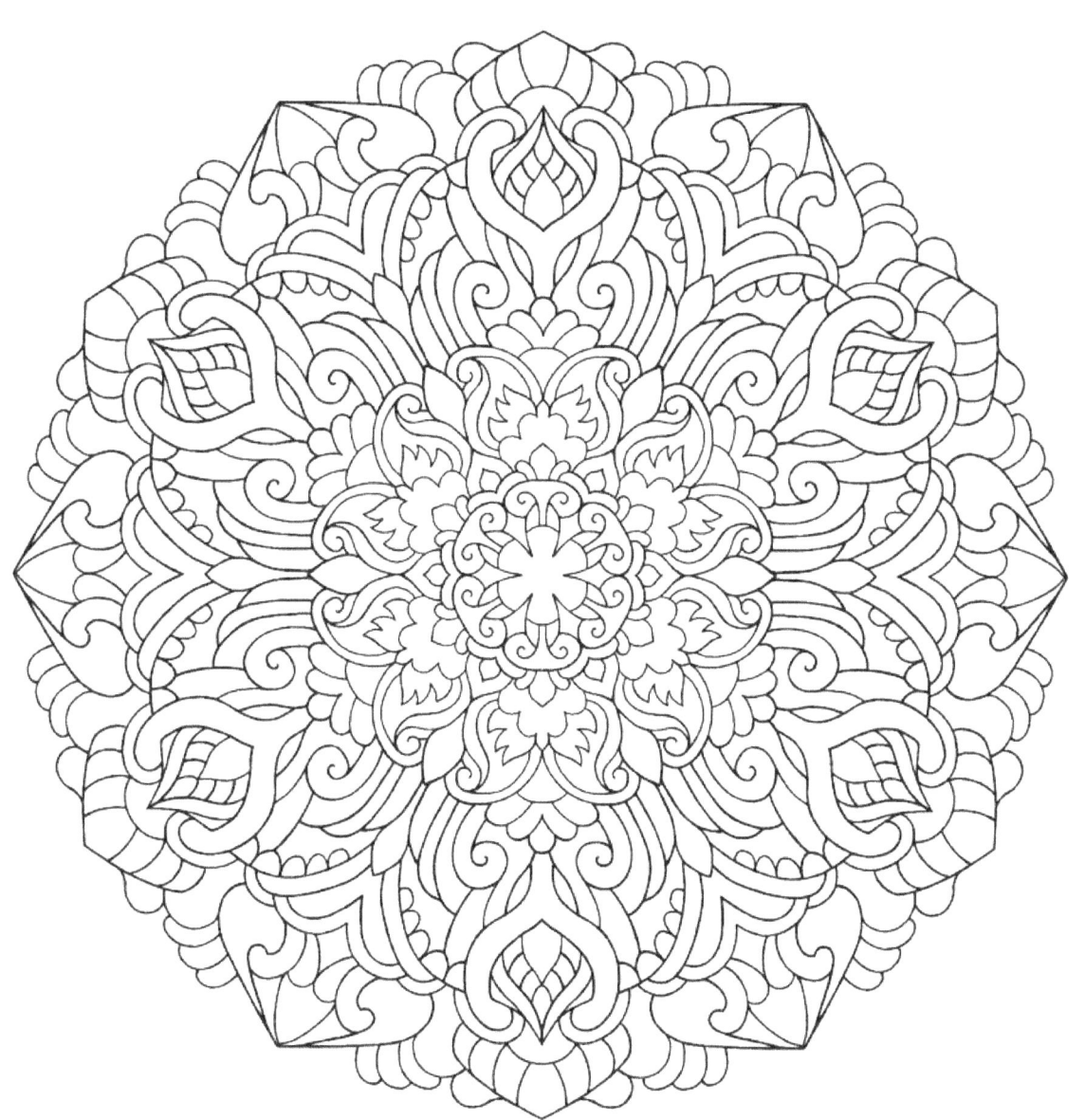

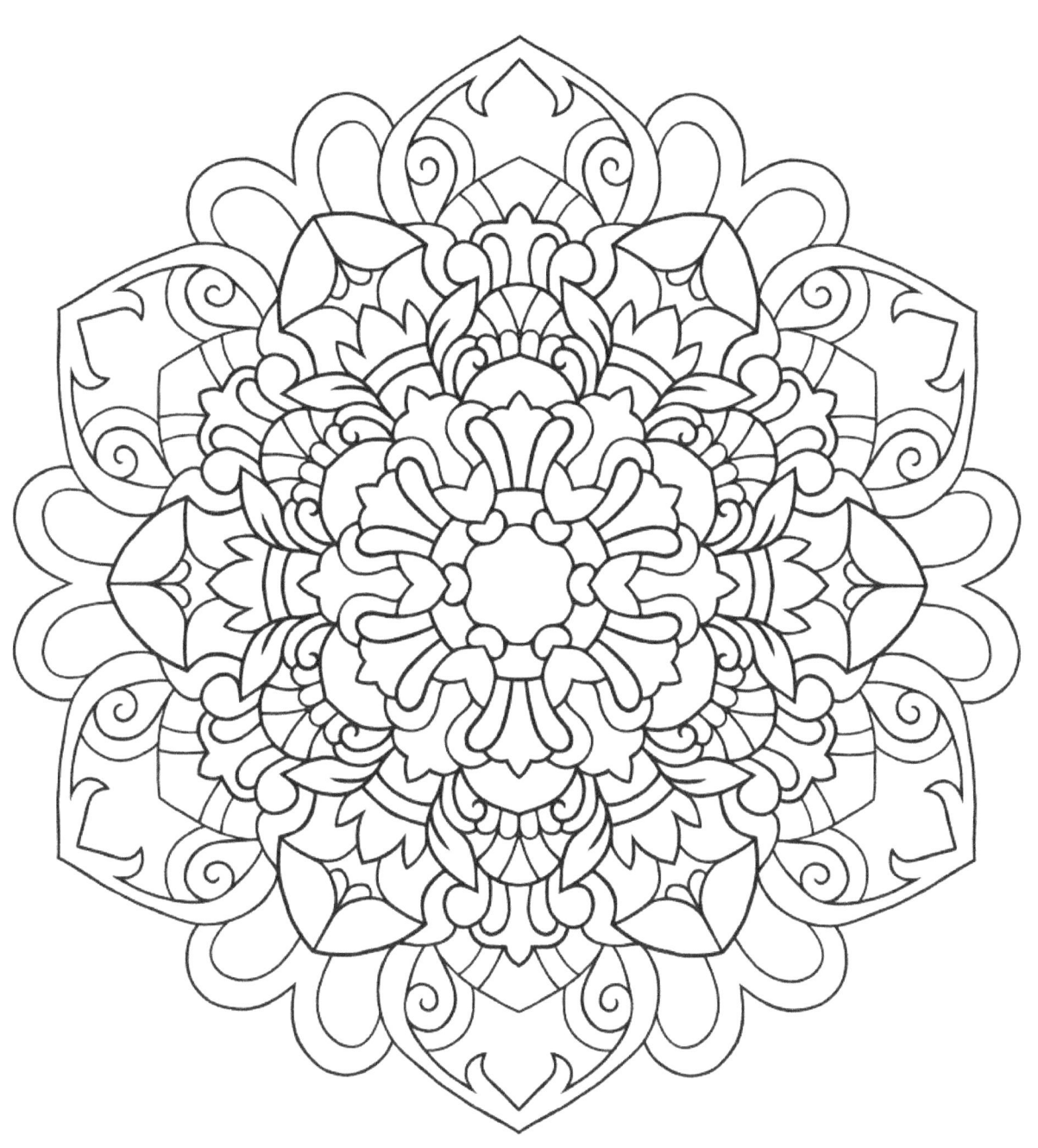

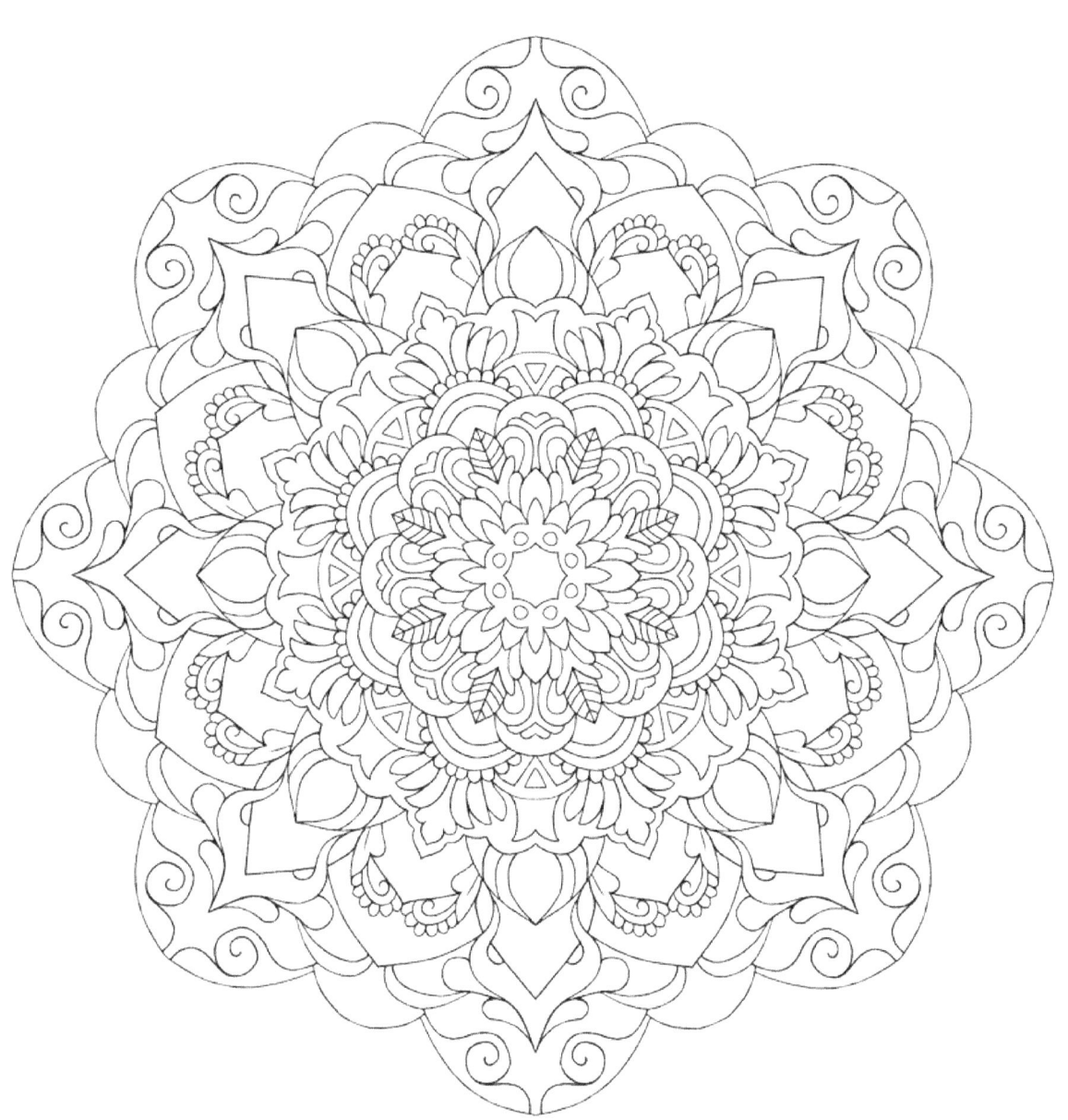

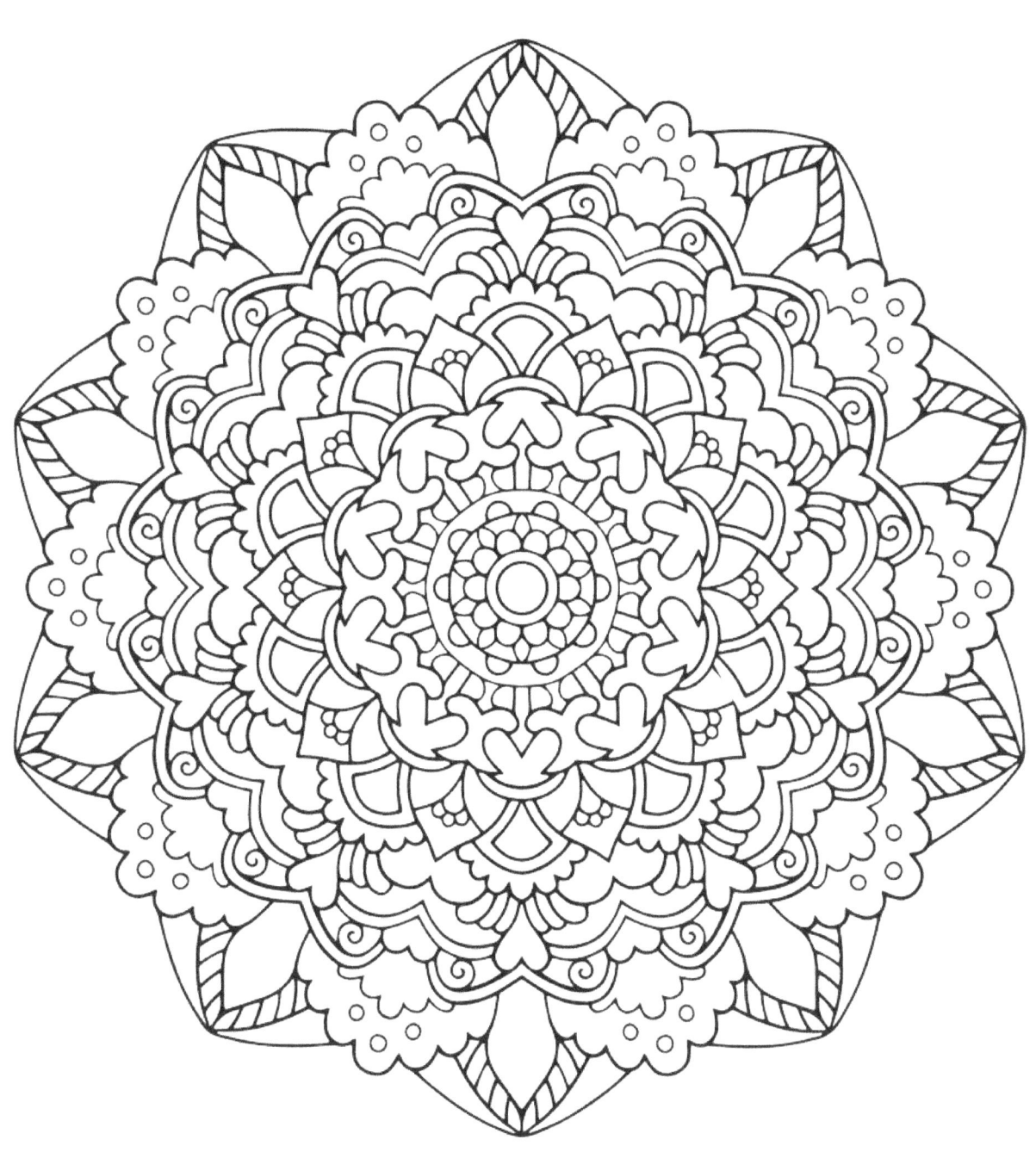

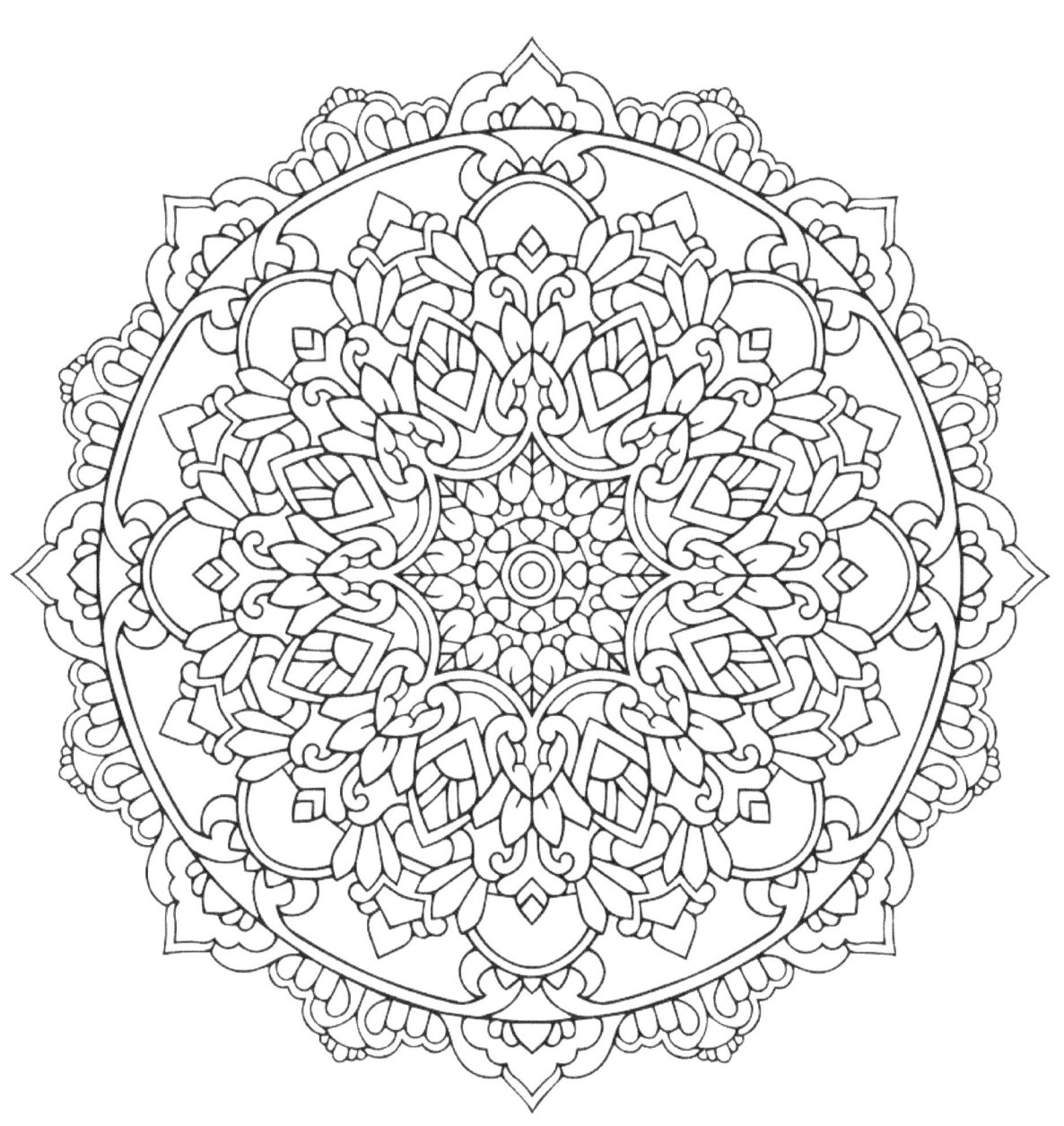

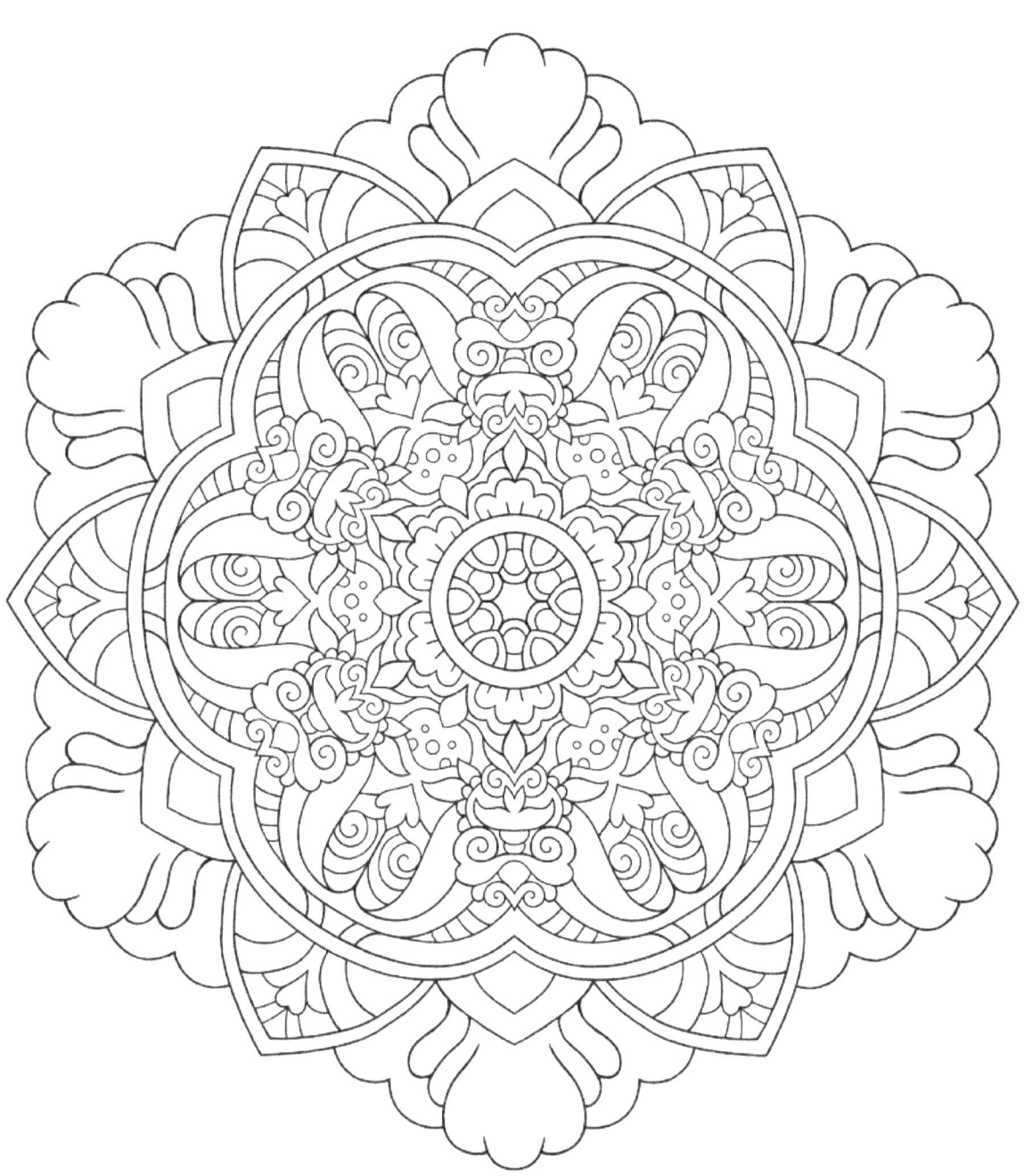

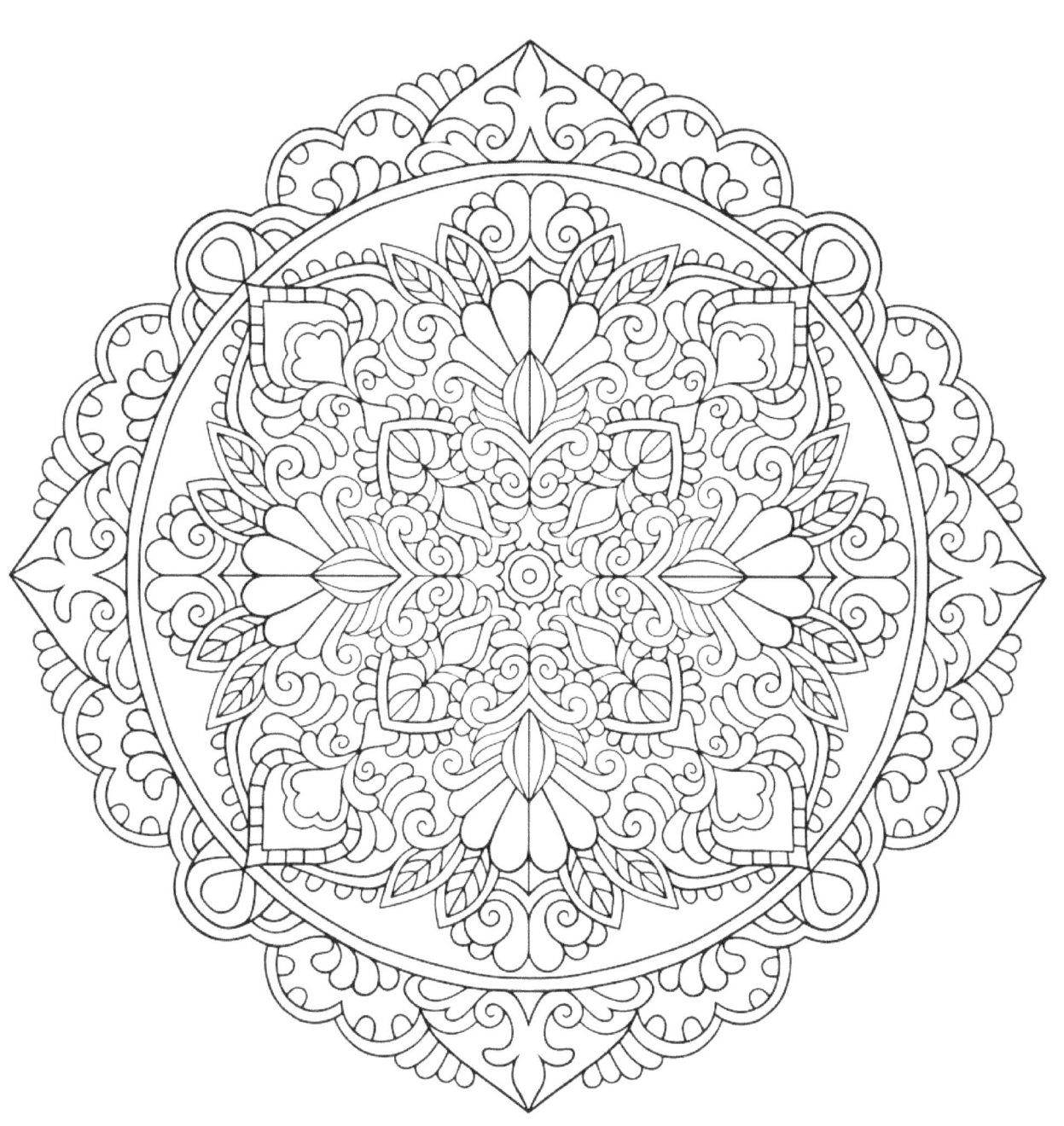

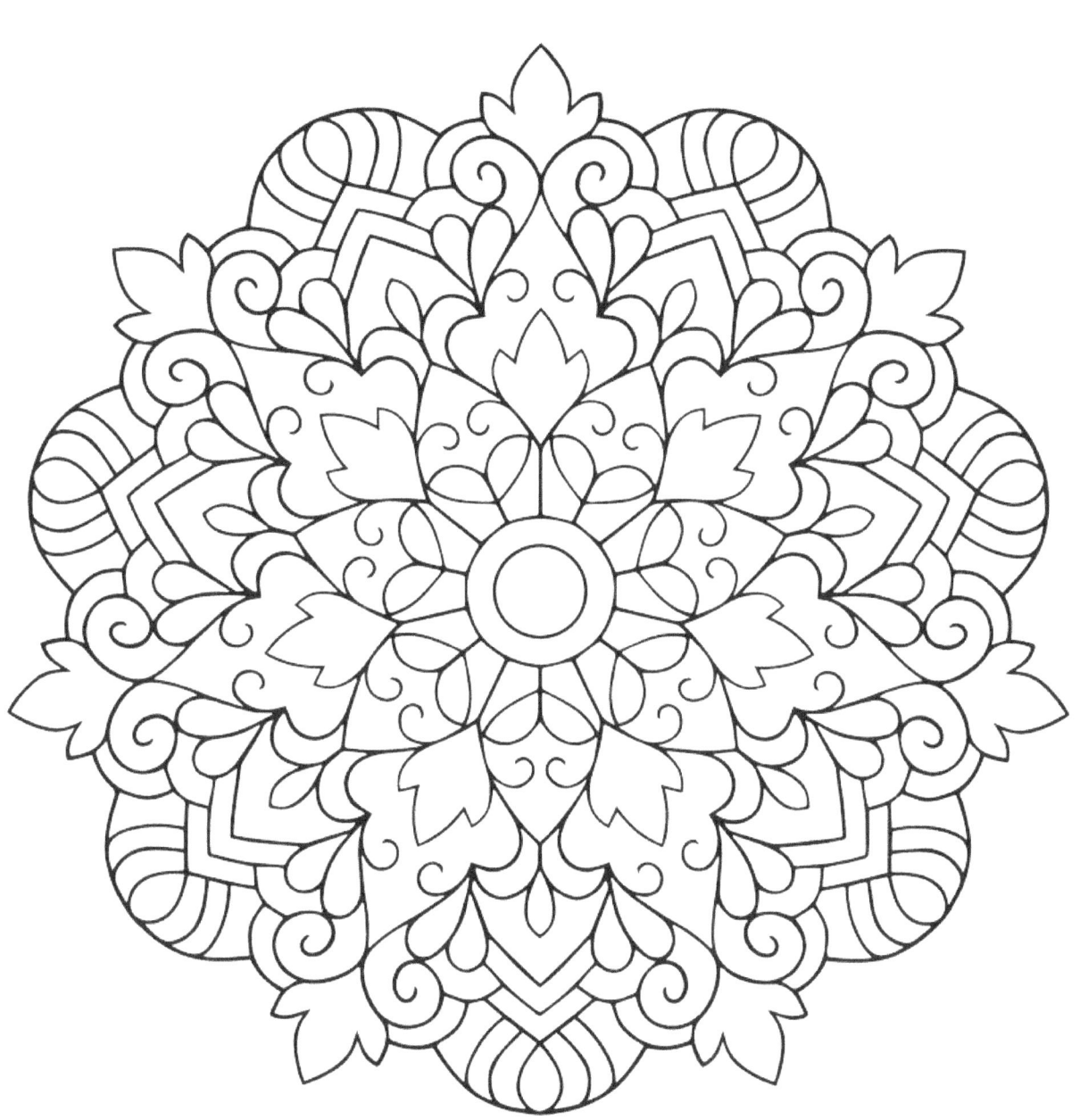

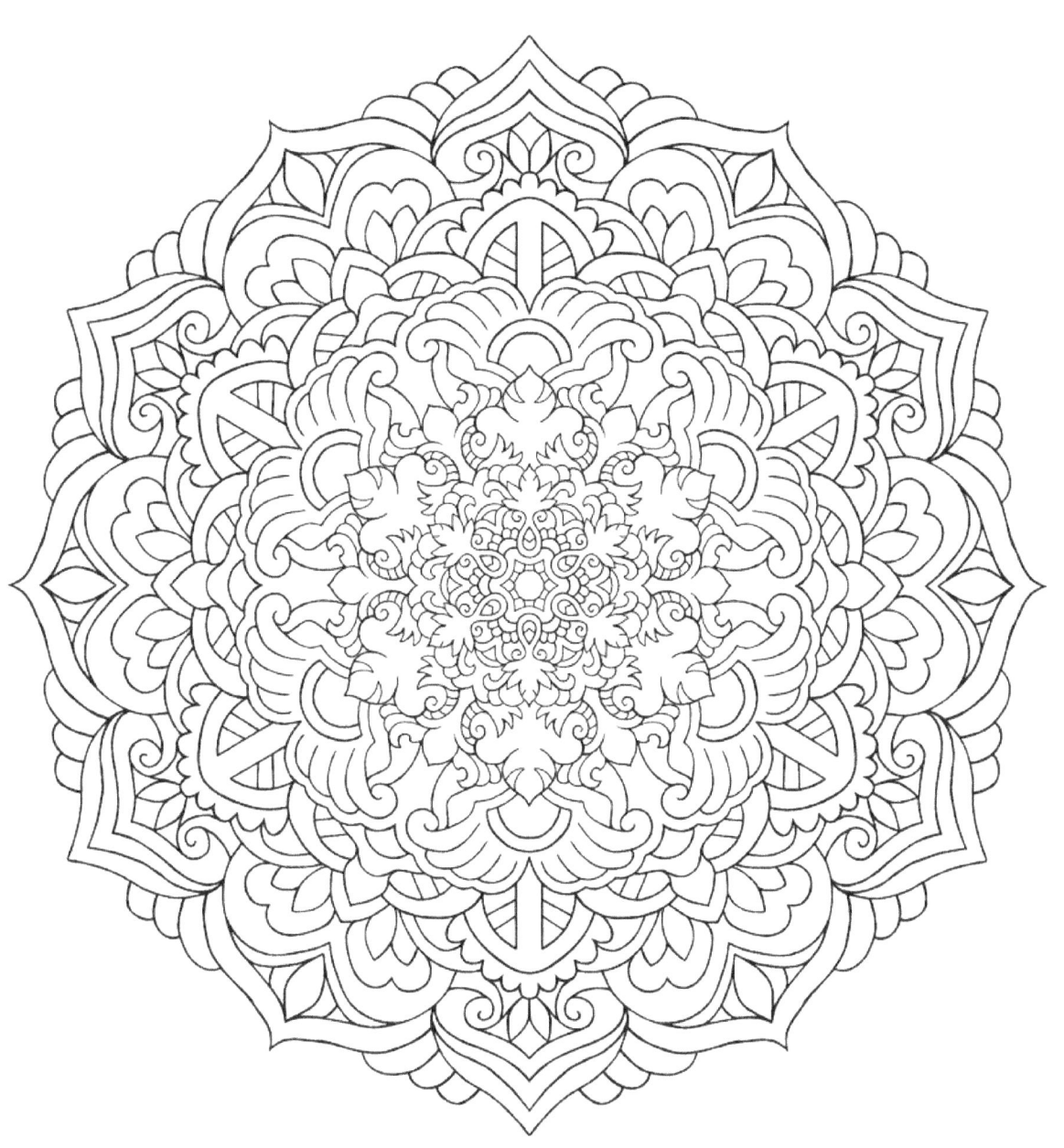

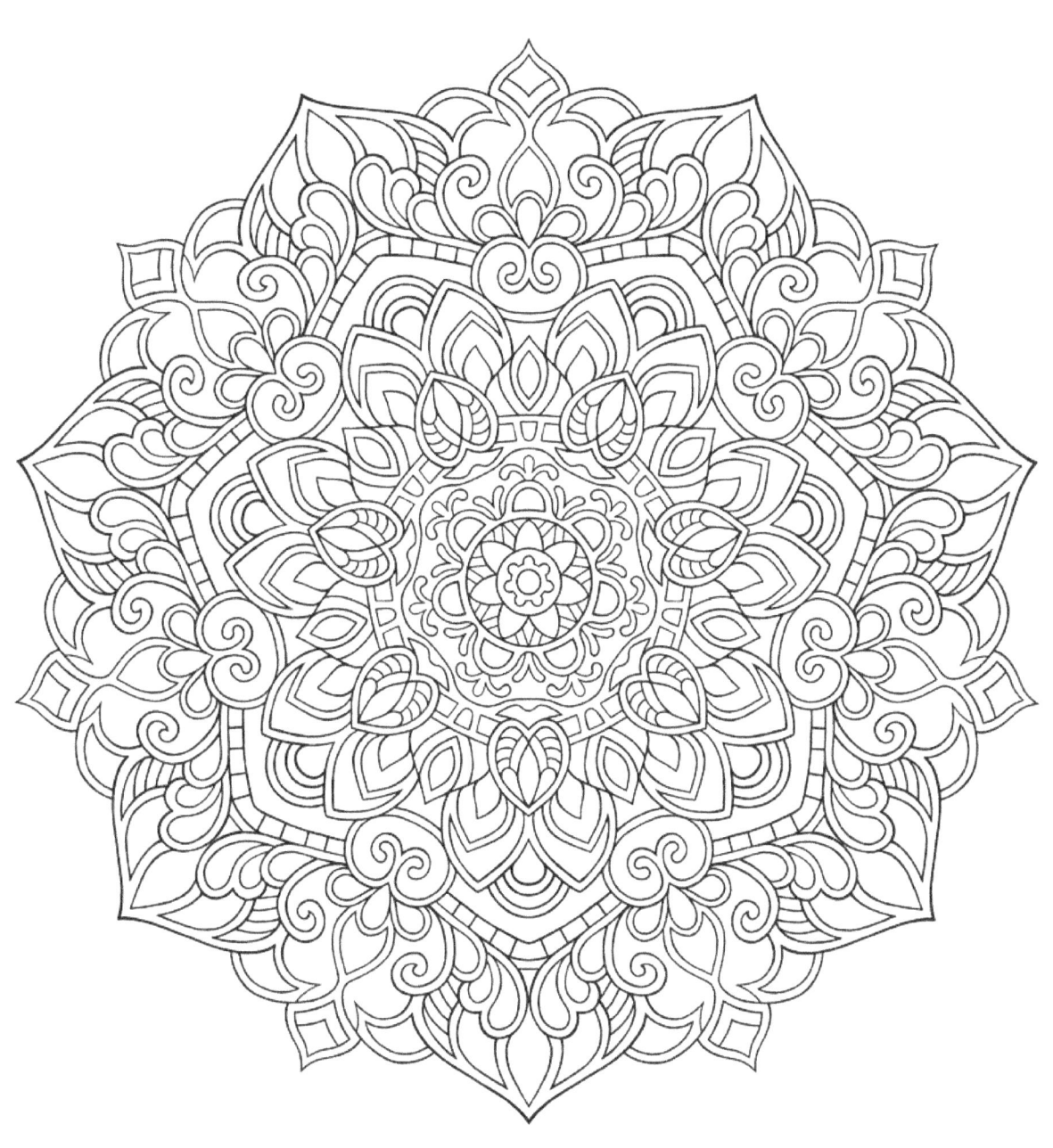

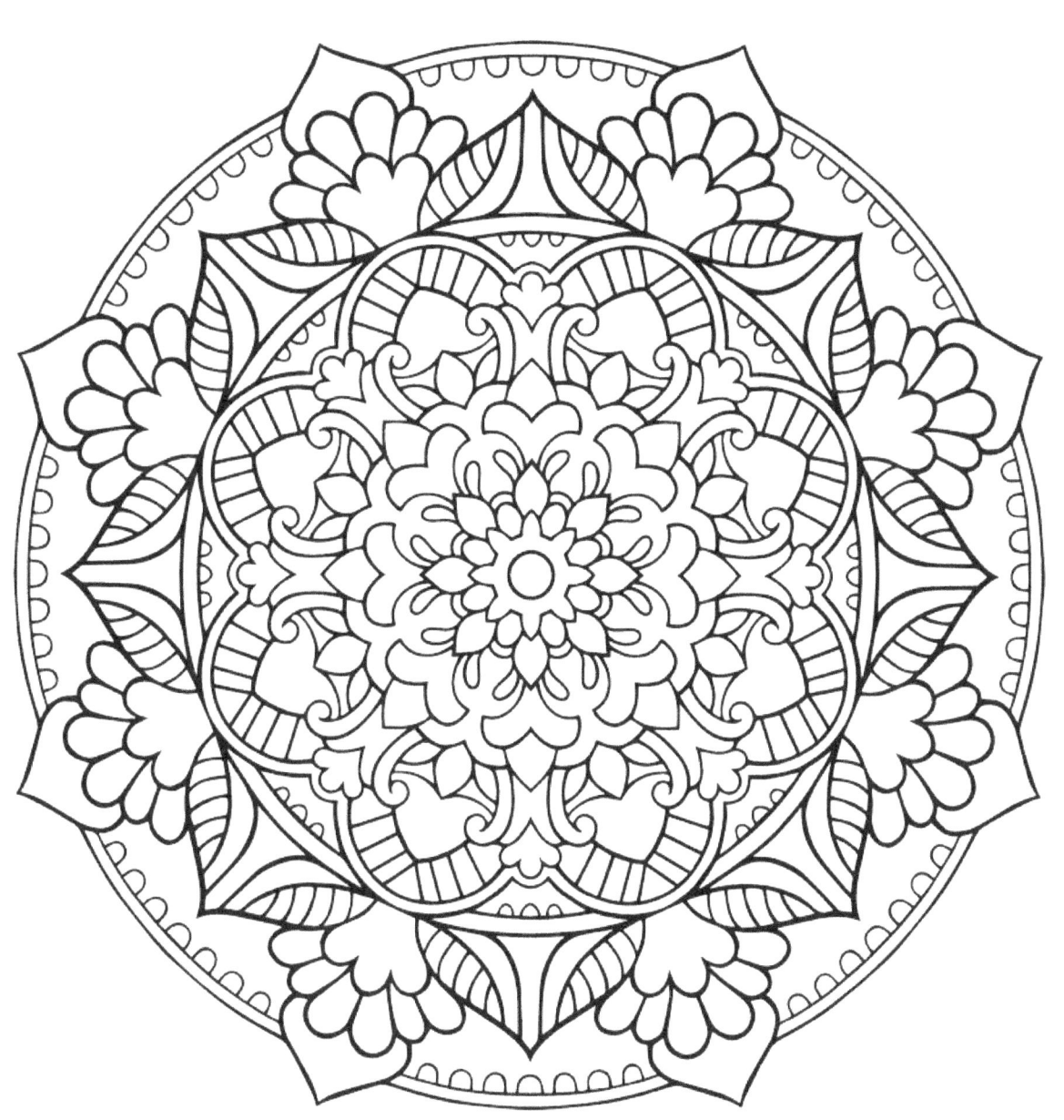

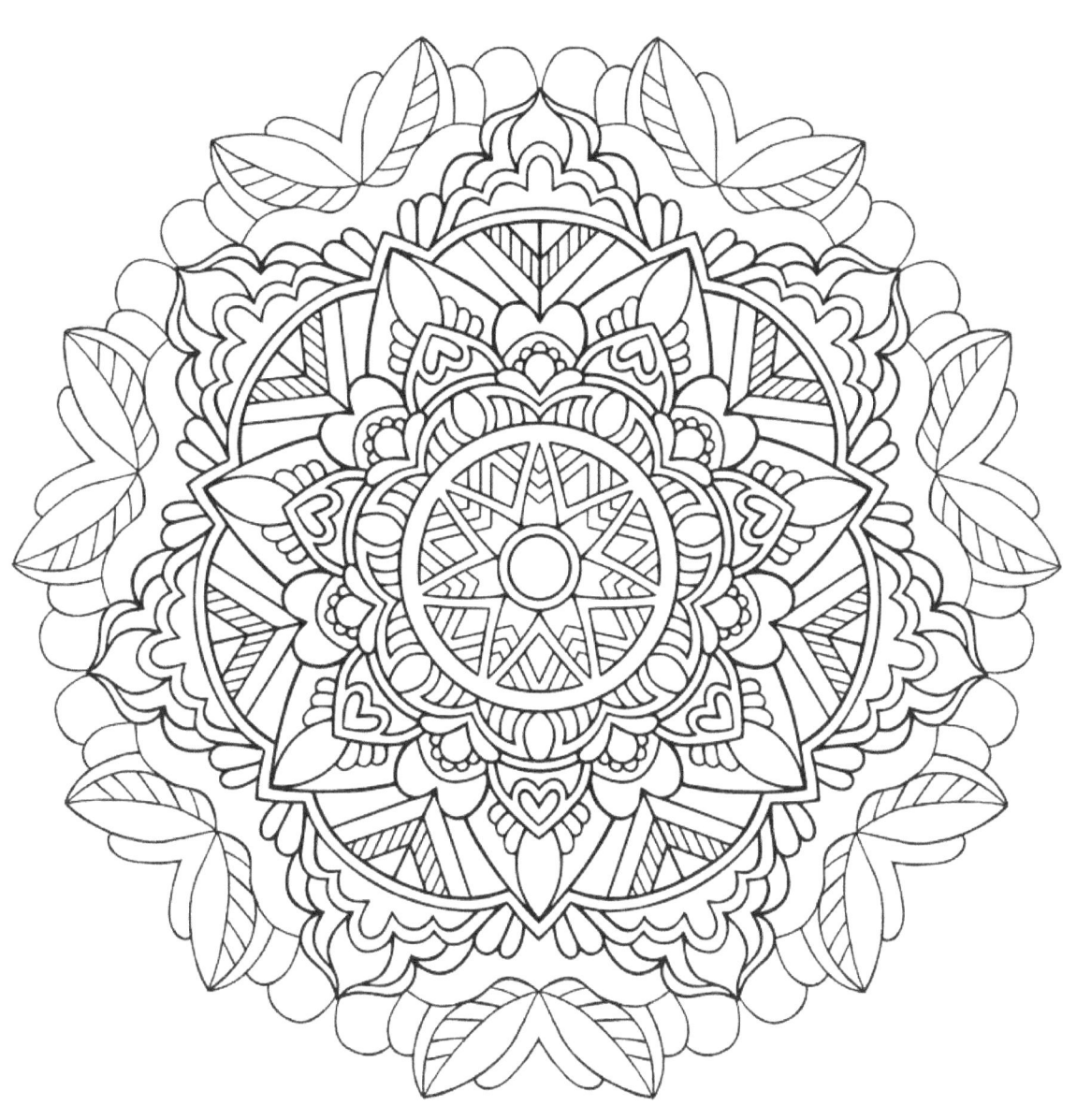

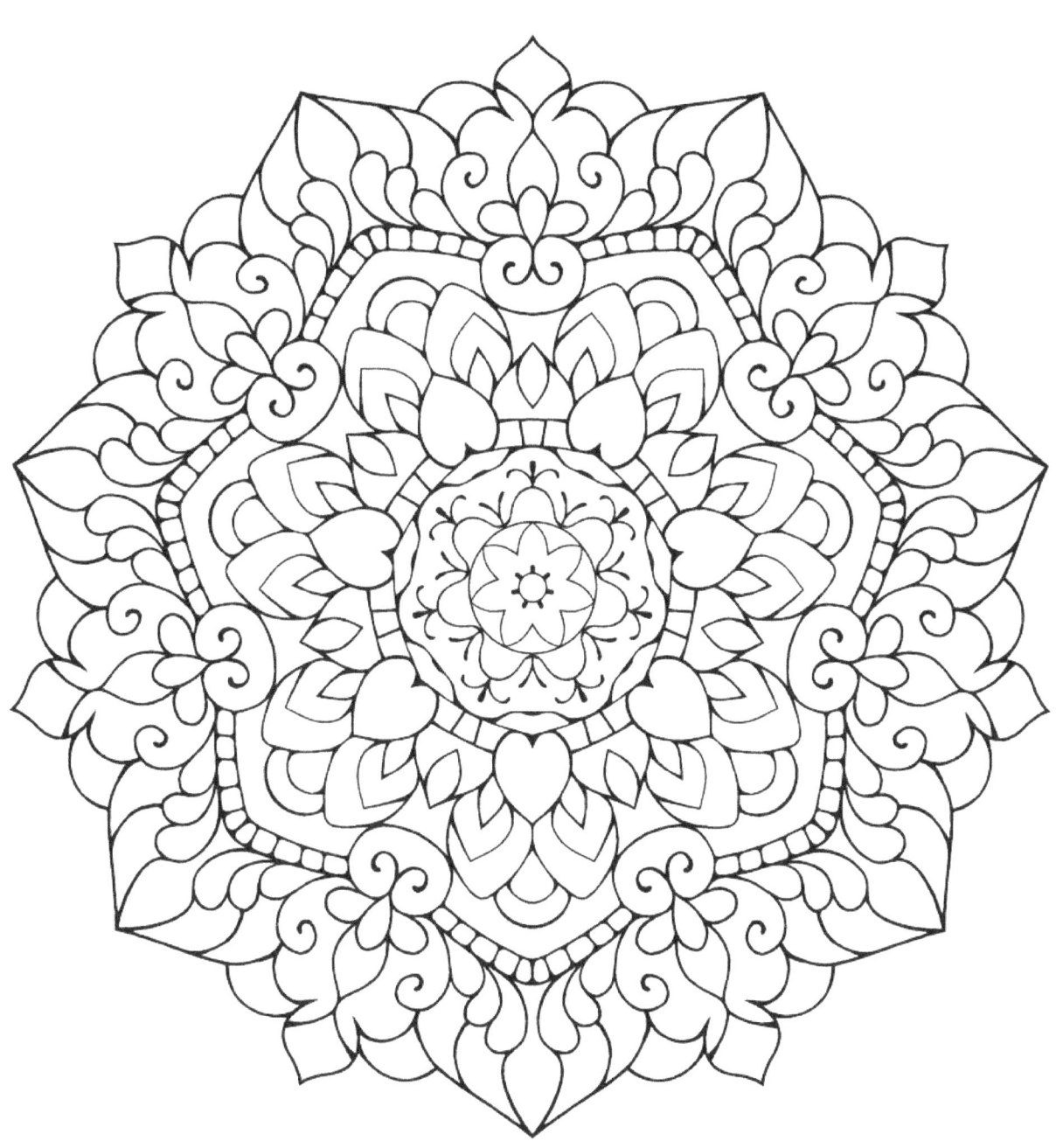

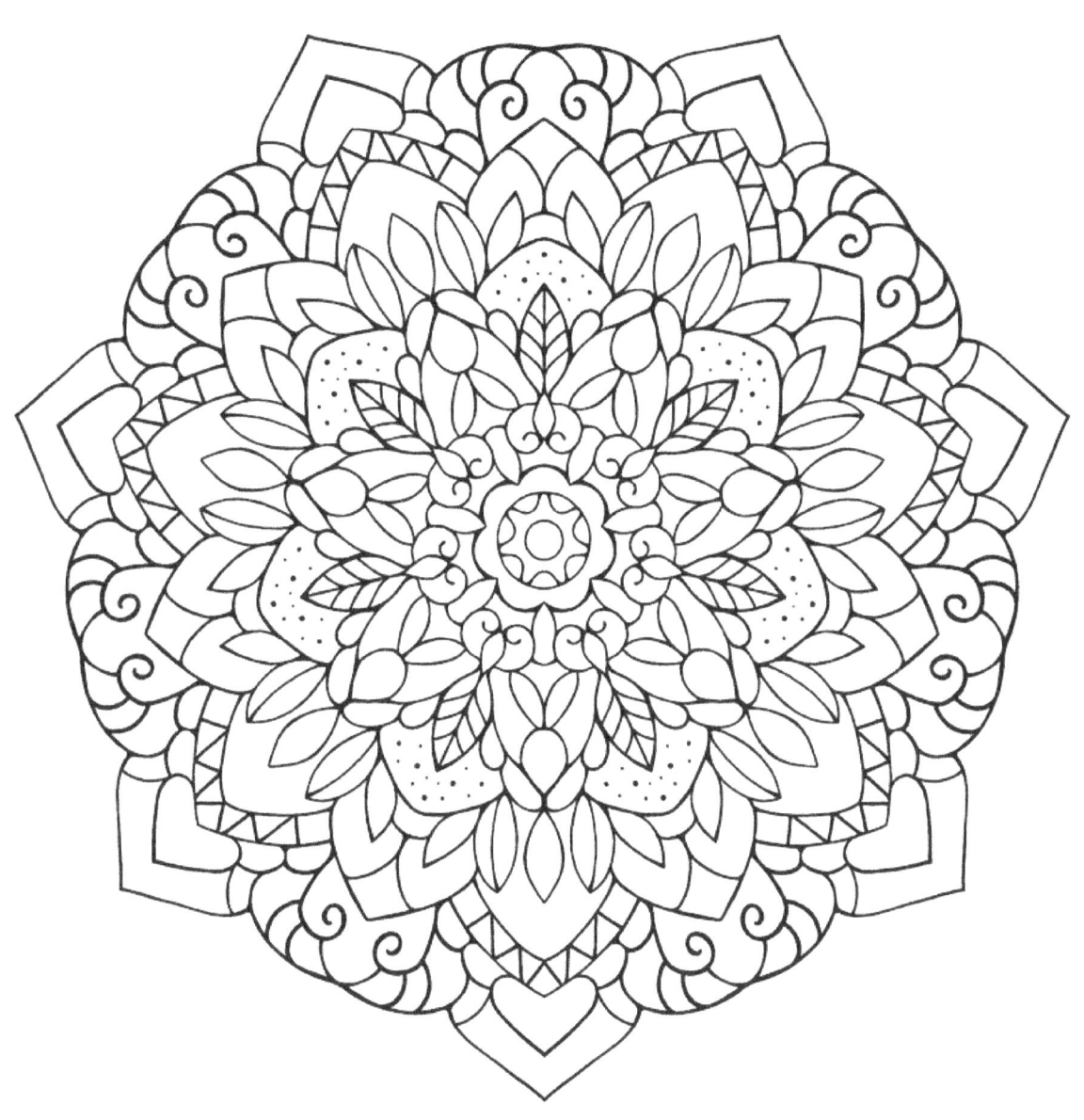

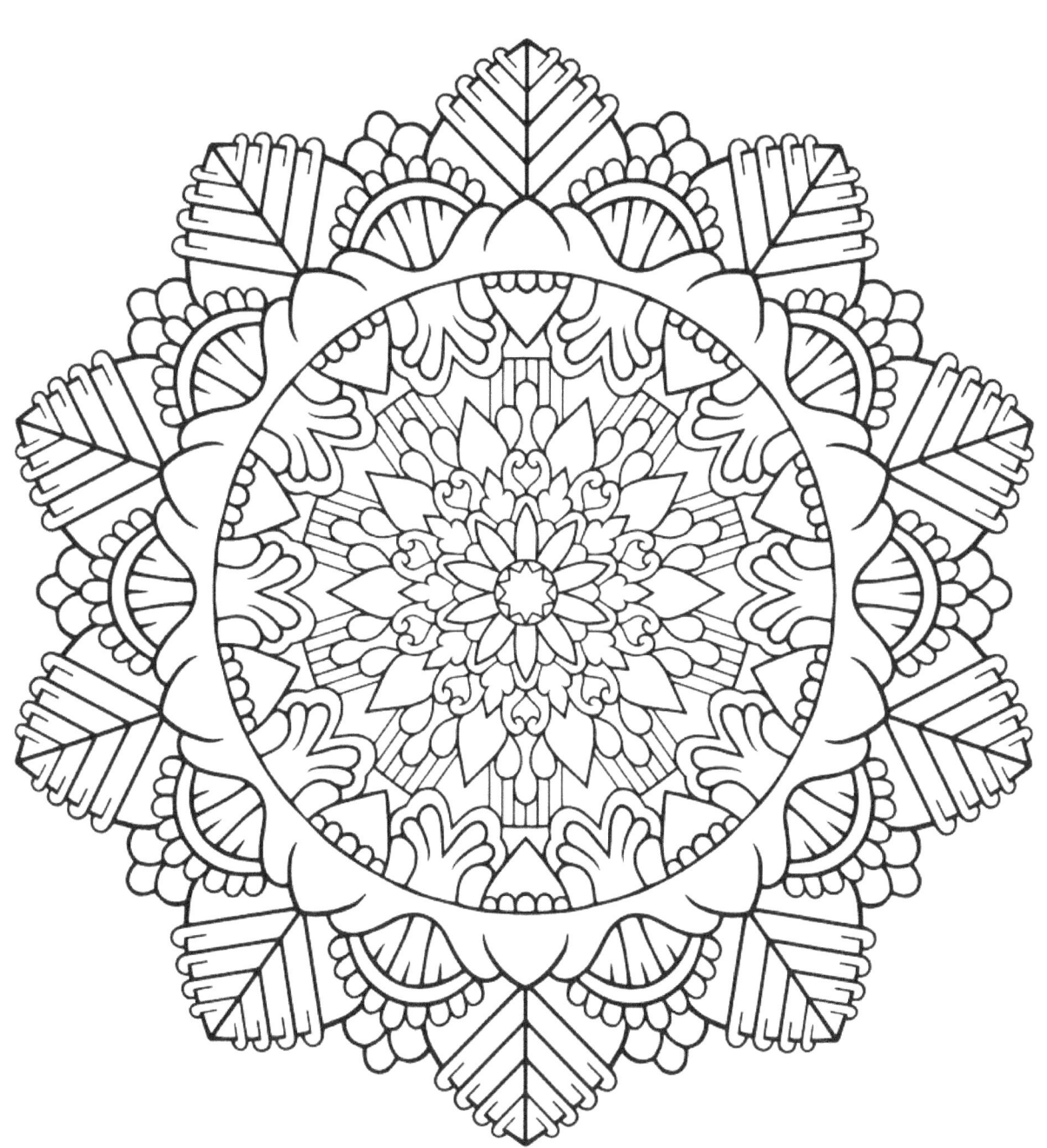

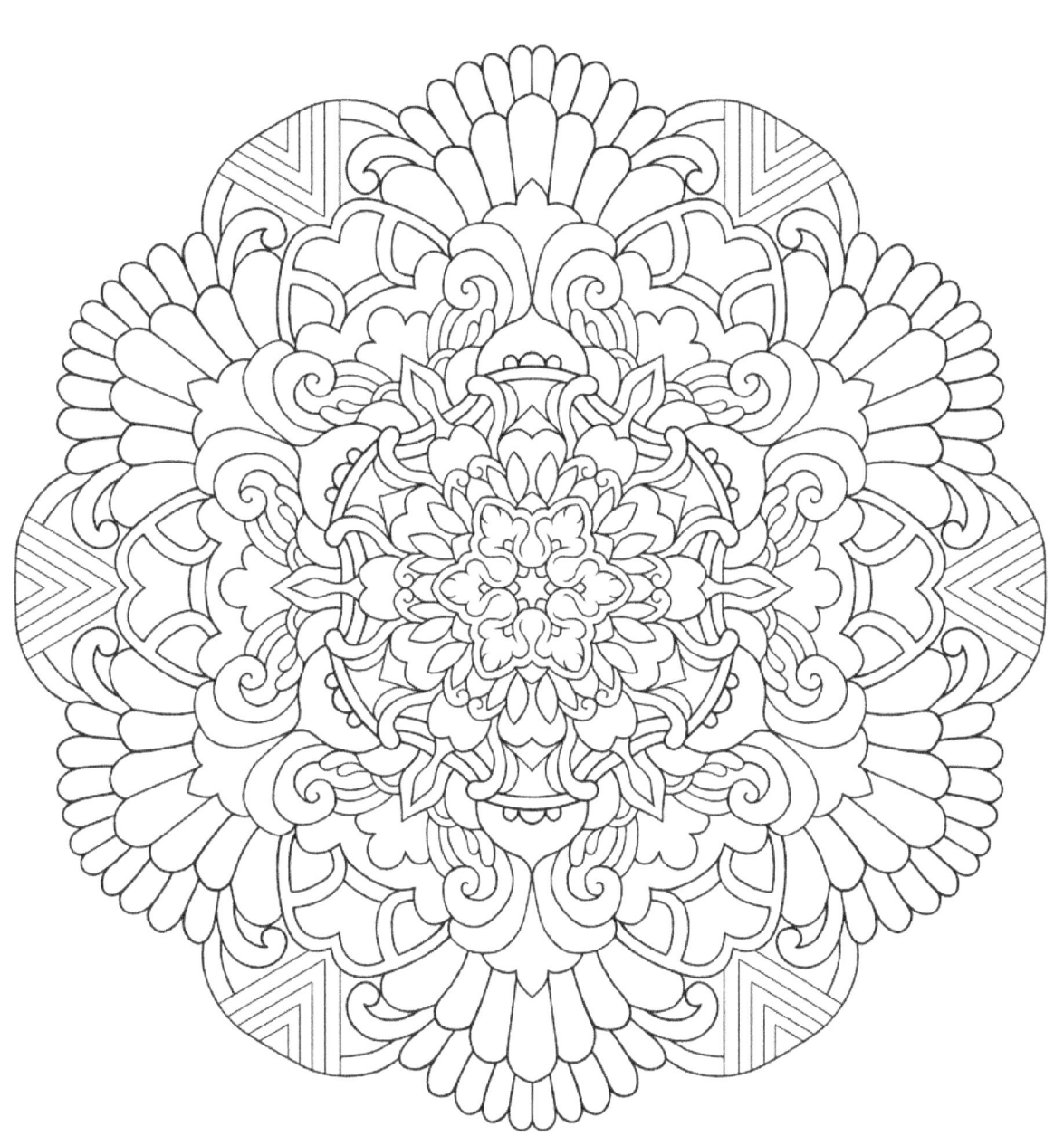

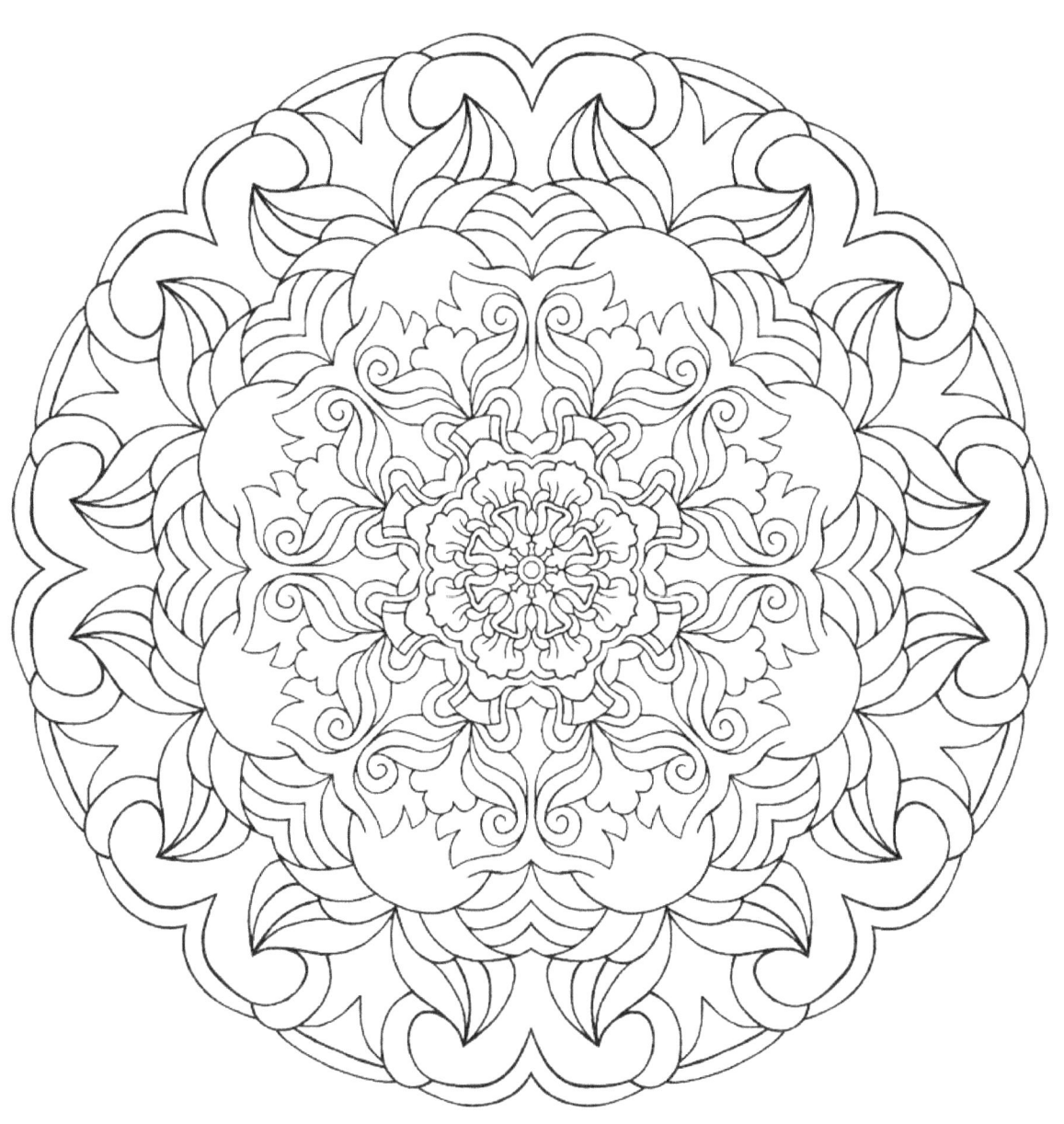

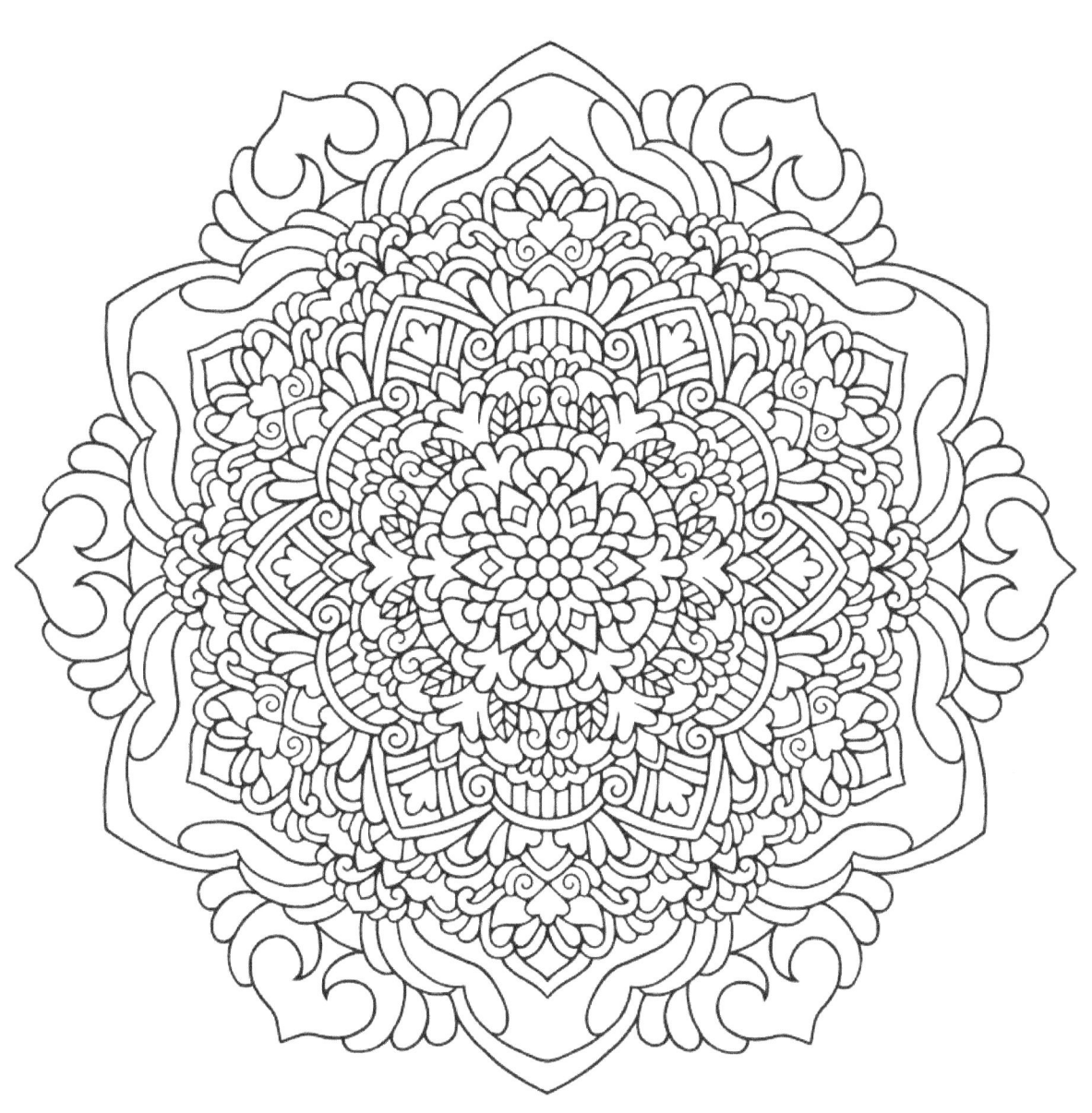

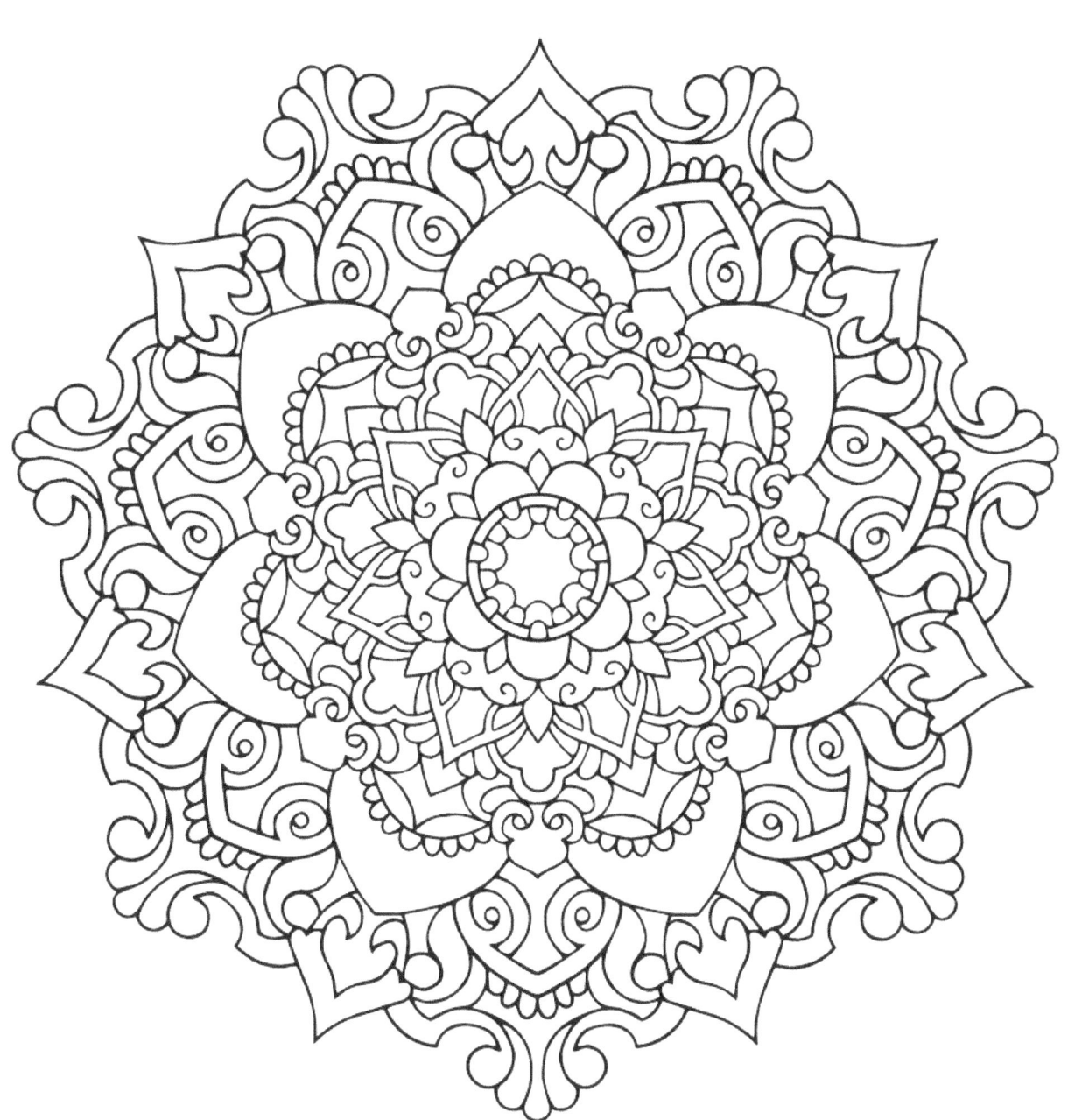

Link to a PDF version: ***www.goo.gl/7Jx9SW***

www.ingramcontent.com/pod-product-compliance
Lightning Source LLC
Chambersburg PA
CBHW080709190526
45169CB00006B/2313